# The Queer Aesthetics of Childhood

# Rutgers Series in Childhood Studies

The Rutgers Series in Childhood Studies is dedicated to increasing our understanding of children and childhoods throughout the world, reflecting a perspective that highlights cultural dimensions of the human experience. The books in this series are intended for students, scholars, practitioners, and those who formulate policies that affect children's everyday lives and futures.

**Series Board**

Stuart Aitken, geography, San Diego State University

Jill Duerr Berrick, social welfare, University of California, Berkeley

Caitlin Cahill, social science and cultural studies, Pratt Institute

Susan Danby, education, Queensland University of Technology

Julian Gill-Peterson, transgender and queer studies, University of Pittsburgh

Afua Twum-Danso Imoh, sociology, University of Sheffield

Stacey Lee, educational policy studies, University of Wisconsin–Madison

Sunaina Maria, Asian American studies, University of California, Davis

David M. Rosen, anthropology and sociology, Fairleigh Dickinson University

Rachael Stryker, human development and women's studies, Cal State East Bay

Tom Weisner, anthropology, University of California, Los Angeles

For a list of all the titles in the series, please see the last pages of the book.

# The Queer Aesthetics of Childhood

## Asymmetries of Innocence and the Cultural Politics of Child Development

HANNAH DYER

RUTGERS UNIVERSITY PRESS

NEW BRUNSWICK, CAMDEN, AND NEWARK, NEW JERSEY,

AND LONDON

Library of Congress Cataloging-in-Publication Data

Names: Dyer, Hannah, author.
Title: The queer aesthetics of childhood : asymmetries of
   innocence and the cultural politics of child development /
   Hannah Dyer.
Description: New Brunswick : Rutgers University Press, 2019. |
   Series: Rutgers series in childhood studies
Identifiers: LCCN 2019002451 | ISBN 9781978803992 (paperback)
Subjects: LCSH: Childhood development. | Sexual minorities. |
   Aesthetics. | Queer theory. | BISAC: SOCIAL SCIENCE /
   Children's Studies. | SOCIAL SCIENCE / Gay Studies. |
   ART / Criticism & Theory. | SOCIAL SCIENCE / Feminism &
   Feminist Theory.
Classification: LCC HQ767.9 .D94 2019 | DDC 305.23—dc23
LC record available at https://lccn.loc.gov/2019002451

A British Cataloging-in-Publication record for this book is available
from the British Library.

Copyright © 2020 by Hannah Dyer
All rights reserved

No part of this book may be reproduced or utilized in any form or by
any means, electronic or mechanical, or by any information storage
and retrieval system, without written permission from the
publisher. Please contact Rutgers University Press, 106 Somerset
Street, New Brunswick, NJ 08901. The only exception to this
prohibition is "fair use" as defined by U.S. copyright law.

∞ The paper used in this publication meets the requirements of the
American National Standard for Information Sciences—Permanence
of Paper for Printed Library Materials, ANSI Z39.48–1992.

www.rutgersuniversitypress.org

Manufactured in the United States of America

For Asa Cy and Casey

# CONTENTS

Introduction: Childhood's Queer
Intimacies and Affective Intensities                    1

1   Queer Temporality in the Playroom:
Ebony G. Patterson's and Jonathon Hobin's
Aesthetics of Child Development                    34

2   Art and the Refusal of Empathy in
*A Child's View from Gaza*                    64

3   The Queer Remains of Childhood
Trauma: Notes on *A Little Life*                    86

4   Reparation for a Violent Boyhood in
*This Is England*                    102

Epilogue: The Contested Design of
Children's Sexuality                    124

*Acknowledgments*                    135
*Notes*                    137
*References*                    143
*Index*                    151

# The Queer Aesthetics of Childhood

# Introduction

## Childhood's Queer Intimacies and Affective Intensities

The child is an emblem of futurity, regularly summoned to draw attention away from past or present conditions of inequality or social instability. And yet, as many parents, educators, and children themselves know, childhood innocence is not assigned to all children in equal amounts. Childhood innocence is a seemingly natural condition, but its rhetorical maneuvers are permeated by its elisions and attempted disavowals along the lines of race, class, gender, and sexuality. That is, despite the familiar rhetorical insistence that children are the future, some children are withheld the benefits of being assumed inculpable. Childhood's perceived innocence, an ostensibly natural effect of natality, animates cultural life in a variety of ways. *The Queer Aesthetics of Childhood: Asymmetries of Innocence and the Cultural Politics of Child Development* interrogates how discourses of innocence constitute material conditions of possibility and violence for children. Beyond conventional tropes and prevailing narratives of childhood

innocence lies a queer terrain of subject-formation, shame, melancholy, and also, hope. My study of the politics of childhood suggests that the child's emotional illegibilities, queer intimacies, and affective intensities, too quickly marshaled to do the work of social norms, find space to breathe in their art and play. Relatedly, I will propose that when adults aesthetically represent childhood experience, they are communing with the queer contours of their own development. Along with deliberations on children's art, I explore aesthetic texts (such as books and film) that are made on behalf of the adult's understanding of childhood. In art by and about children, insight can be gleaned into how histories of sexuality, gender, nation, and race become entangled in theories of childhood.

This book names that which childhood innocence seeks to repress or disavow as "queer" and proposes that children's art and play can provide insight into how damage to queer desire and relationality is caused. My study, then, makes the argument that the utopian force of childhood is not its inherent innocence but its potential repair of stagnancy, repressed memory, and historical ruin. While emphasizing children's aesthetic interventions into social norms, I develop a queer theory of childhood to analyze and articulate resistances to the vocabulary and attendant material habits of childhood innocence. In turning to the realm of art and aesthetics, I suggest that expressive cultures of childhood produce forms of sociality that can evince new affective ties and ethical interactions between children and adults. Critically studying the rhetoric of childhood innocence is indispensable to opening new futures for children that are accountable to the histories of social violence they inherit. For the child, the future anterior of development, where a series of becomings is expected

# INTRODUCTION    3

to culminate in knowledge and reason, is subtended by hierarchy and inequality. Itineraries of global capitalism, environmental ruin, and colonialism form the geographies in which children are raised and, for many, create vulnerability. In an effort to consider the residues of historical trauma and contemporary biopolitical formulations of life and death on child development, this project recognizes how histories of colonialism extend into the future. Interrogating the structure of affective, epistemological, and political attachments to childhood in contemporary culture, this book is interested in how the rhetorical force of childhood innocence reverberates in our treatment of children.

A future of possibility and hope for children who experience vulnerability, violence, and trauma relies on the adult's ability to support the child in aesthetic representation of suffering. When taken seriously, the child's acts of imagination can move us away from what is taken for granted as truth. Children's drawings and make believe are often dismissed as leisure and as negligibly important to the social and political world. Yet, in their art and play, children can resist knowledge and stage an encounter with the affective life of curiosity. What if we understood children's cultural productions as efforts to symbolize the queer affects of development? What would it mean to understand children's development as a struggle against letting go of queer affect? What could happen for the adult's politics and sense of well-being if we took seriously the ways that aesthetic experience can cause interruption to the symbolic contexts in which one grows up? I meditate on these questions and propose that in the visual and aesthetic cultures of childhood we can glimpse an indeterminate future that doesn't calibrate injustice but locates

hope in the wreckage of violence. *The Queer Aesthetics of Childhood* treats children's cultural expressions and representations of childhood as affective and political territory that can call into being altered forms of social life and disturb ontologies of sex, race, and kinship. We might, for instance, observe a child's drawing for its reimagining of community and intimacy; we might notice how the child endows landscapes, buildings, and stuffed animals with affect; or we might notice the ways the child extends life to rocks and toys.

Within the creative expressions of childhood reside epistemic and social possibilities for renewal and rearrangements of the larger sociopolitical environments into which they were born. In asking what can happen if we let our theories of childhood be affected by the social imaginaries conveyed in childhood's aesthetic expressions, I hope to activate a new theoretical framework within the field of child studies. *The Queer Aesthetics of Childhood* brings queer theory to bear on childhood studies so that normative formulations of childhood that restrict children's imaginations can be better resisted. When differently attuned to the social and emotional spheres of child development, concerned adults might help children work through the affective legacies of colonial traumas, the constraints of homophobic social orders, and the classed dimensions of schooling and education. My analysis is motivated by a belief that the aesthetic expressions of childhood can provide insight into how histories of sexuality, colonialism, gender, and nation become entangled in theories of child development and, in turn, can wound children's subjective realities. Queer theory, I aim to show, can help to replenish child studies by giving language to the child's creative resistances against normalcy. As queer theory has shown,

queerness inheres in disruptions to conventional formulations of sex, gender, and reproduction, but "queerness" also arises, more generally, from an object's veering away from expectation. Here, "queer" references nonnormative gender and sexuality but also all that is deemed strange and unruly. Taking my cue from Kathryn Bond Stockton, Rebekah Sheldon, Julian Gill-Peterson, Erica Meiners, and other scholars who are re-forming queer and trans theories of childhood, I use queer childhood as an organizing construct that helps to theorize anxieties about the future of gender, race, and sexuality. As a supplement to the body of knowledge they present, my study seeks to further honor children who are not interpolated or respected by normative developmental theory. The qualities of the term "queer" facilitate analysis of how desire, affect, and fantasy that are not publically sanctioned get educated in the process of growing up. Heather Love provides a version of queer theory that has resonance here. She writes: "The semantic flexibility of queer—its weird ability to touch almost everything—is one of the most exciting things about it. . . . The word still maintains its ability to move, to stay outside, to object to the world as it is given (2011, 182). Allowing queer theory and child studies to thicken together, this book deepens understanding of the impact that cultural debate has on children's psychological development.

Each chapter in *The Queer Aesthetics of Childhood* makes its own intervention into discourses and debates about childhood development, but taken together the chapters create an aesthetic archive of childhood on a transhistorical and transnational stage. Interested in the affiliations between social experience and the child's psychological interiority, the arguments made here center children's creative expressions of

## 6    THE QUEER AESTHETICS OF CHILDHOOD

historical trauma, the injustices of innocence, and the tyranny of adult authority. This book moves between diverse sites and scales, including a study of children's art made after experiencing war in Gaza, a film about boyhood and the psychic life of racism in England, a novel about gay love and childhood trauma, photographs, and an art installation about the politics of childhood. I also enter into debates about children's sex education. I discuss not only art made by children but also art made by adults on behalf of their conceptualizations of childhood. The debates and events that I mesh together offer an interdisciplinary study of the aesthetic cultures of childhood, all the while emphasizing the child's creativity and play as powerful for their ability to create hope. Cultural texts that depict children and childhoods can operate as symbolic resources, as they carry the potential to awaken and assist in redescribing repressed histories of individual and collective suffering.

The queer contours of childhood are those that exceed the confines of normalcy and resist normative assessments of emotional and social growth. The term "queer childhood" helps to name and theorize the remnants of infantile life and primordial struggles to protect curiosity and imagination. It is not my intention to suggest that all children possess queer sexualities or identities, nor am I invested in hard-lined predictions of the gender or sexual identity they might claim in the future. Rather, I analyze aesthetic texts that induce or touch queer affect. In deepening the conceptual terrain of child studies and showing what insight can be gleaned from the symbolic realm of representation, I am inspired by literature in the field of affect theory (Chen 2012; Georgis 2013; Ngai 2005; Sedgwick 2003) and psychoanalytic studies of cultural

# INTRODUCTION

expression (Cheng 2001; Eng 2010; Farley 2018; Musser 2014, 2018). For Dina Georgis, queer affects are in excess of the socio-symbolic order and arrive to us "as surprise or interruption, . . . suspending knowable or teleological time and unhing[ing] proper boundaries and habitual social relationalities" (15). My thesis rests on the proposal that queer affect runs wild in the aesthetics of childhood. In childhood's creative art and play, and art about childhood, it is unleashed and finds its way into the social world. In witnessing children's creative expressions and art about childhood, the adult can be invited to re-enter an originary space of loss, mourning, and hope. In children's creative expressions queer affect pushes against normativity and social regulations so that a new future can be conjured. Further, traces of queer desires that resist repression or can't be disavowed reappear in aesthetic representations of childhood. I rehearse Georgis's arguments on a number of occasions throughout this book because they have helped to form a foundation on which I have developed a recognition of the emotional life of aesthetic experience. Queer affect, she explains, is the return of "impossible desire," the unassimilated or "unrecognizable desires" that haunt symbolic order (15). Queerness, drawing on Georgis, may be theorized as the repressed content of normative development; that which must be discarded in order to "grow up."

For the purposes of this project, affect is defined beyond just an emotion or sentiment felt by a single subject. As Chen (2012) explains, it is also the state of being moved or "affected," and this can happen both individually and collectively. Teresa Brennan provides a template for thinking of affect this way in her 2004 book *The Transmission of Affect*, in which she argues that "the person is not affectively contained" (2) and thus, we

feel the other's affects. Brennan distinguishes affect from feelings because, for her, feelings are "sensations that have found the right match in words" (5). Brennan suggests that we project unwanted affects onto others, particularly those who are marginalized by race, gender, sexuality, and citizenship. But as Kyla Schuller makes clear, "The contemporary notion of affect is chimerical, suturing two distinct capacities—that of emitting impressions and that of absorbing impressions—into one apparently seamless whole" (2018, 13). Sylvan Tomkins's (1962) placement of affect deeper in biological and psychological life is respected here for its capacity to conceptualize impulses and drives not yet attached to the representational world of emotions. But equally valued is Sara Ahmed's framing of "affective economies," where emotions bind people together and to objects, as much as they cause abjection and friction. Ahmed explains that "emotions may seem like a force of residence as an effect of a certain history, a history that may operate by concealing its own traces" (2004, 119).[1] These traces, though, are not disappeared, and they return to haunt the subjective life of collectivity. Georgis might term such abjected matter "queer affect" because it has no home in the social world.

My own embrace of affect theory arises in large part from its ability to describe the infant and child's instinctual loving, hating, aggression, and joy, and the reparative potential for art to commune with and express feelings, sentiments, and emotions. Under the ideological sway of innocence, negative affects are often expected to be divorced from childhood experience. The symbolic value of innocence is, in part, its ability to raise public alarm about the child's potential exposure to negative affects. Relatedly, children's rights are

vehemently asserted in the field of child studies, but the child's own negative and difficult affects, such as anger, hate, and resent, often a result of insecurity, are generally undertheorized. This book calls these affects queer in order to show how complicated the interior and social world of the child can be. Cultural debates about childhood innocence can loosen queer affect that has been obstructed by an education in normalcy.

For Georgis, queer affect offers an occasion for learning because it unsettles the stories we tell about ourselves and others (in this case, the stories we tell about childhood). Queer affect, for Georgis, is a result of memory discarded because it is difficult to bear but which nonetheless can return in encounters with art. In children's art and play, what is taken for granted is often broken down and reimagined, as queer affect pushes against their ability and desire to mimetically represent the social world and its habitual restraints. In this way, children can tell a new story of relationality and subject formation because they are given a wider margin to express creatively and possess what Adam Phillips calls less affectively organized selves (1998). Attendant to this line of thinking is a broader insistence that art allows us to inhabit alternative narratives in which the past returns and is remembered for its ability to clarify the psychosocial dynamics of the present. In art, such as novels, film, and drawing, "difficult realities are worked-out" (Georgis, 77). While in some fields of study and teaching this may be assumed, in the field of child development, often underscored by psychological and sociological methods, the usefulness of art is not always agreed upon. Beyond the repeal of "proof," cultural production and art can operate as a countersite to sanctioned national histories and gendered embodiments, and release unassimilated conflicts

not previously represented or sufficiently expressed. The aesthetic texts that I examine are treated as useful for the openings they create into dialogue about the queer contours of child development.

From within the field of queer childhood studies, my work gains distinction for the equal respect it pays to the social construction of childhood *and* the social injunction to care for children. In underscoring the benefits for queer theory to carefully attend to the pressing needs of the developing child, this book uniquely convenes collision between the figure of the child as symbolic of social conflict and the embodied and material effects of human development. The field of child studies is often polarized between those interested in psychologically determined questions of human development and those interested in sociocultural questions of environment. For sociocultural scholars of childhood, the child exists within an ecological field of social and cultural influences, while for more psychologically and biologically informed theories of growth, the bioinformatics, quantitative, and neurological variances of child development are important. Here, the psychology of the individual is continuous with the individual's environment, and psychic and social pressures to adapt to normalcy are deeply entwined. My purpose is not to reinvest superiority in either side, nor in the humanities' approach to studies of childhood that emphasizes literary, textual and cinematic archives. Rather, *The Queer Aesthetics of Childhood* is interested in the complex affiliations between processes of social belonging, aesthetic expression, and the child's psychological interiority. Taking the child's material vulnerabilities into account while also drawing from critical theory's insistence on the fantasies and illusions that subtend

subjectivity, I detail a theory of childhood that is in direct conversation with all three orientations to the field. In doing so an interdisciplinary relationship between literature and methods often deemed at odds or incompatible is used to invite questions about the embodied vulnerabilities, educational effects, and narrative implications of growing up. Beyond disciplinary enclosures, childhood studies, with its focus on redefining the conditions of development, and queer theory's considerations of the violence of normativity, collaborate to form an interpretive method that uniquely theorizes aberrances between the myth of childhood innocence and the lived experiences of children.

My interdisciplinary mode of investigation causes this book's discussion of childhood to move between real children, embodied childhoods, and references to childhood as symbolic and phantasmic figuration. My reference to the child as a product of adult anxieties and epistemologies, specifically a philosophical figuration of childhood, often travels into discussions of real children and their material social inequalities. My concerns about the manipulation of childhood for the adult's political agendas shift this book back and forth from conceptual theories of childhood to concerns about the political and state-sponsored treatment of children. The uneven pace of advances in children's rights means that we might do well to question the symbolic value of innocence because it is not a privilege afforded to all in the same amounts. In interrogating how the fragile boundaries between adulthood, adolescence, and childhood rest on the rhetoric of innocence, I offer a rethinking of development and the working ontologies that pivot on and collude with hierarchies of age. In turn, I invoke inquiry into the political consequences of this

hierarchy, leaning into compulsions to care for children not because they are inert objects in need of knowledge and mastery but because they are agential subjects who make vital contributions to sociopolitical life. My background in child studies is also inflected by commitments to feminist critiques of global capitalism, settler colonialism, and imperialism. Thus my analysis of childhood builds on the feminist acumen that social relations are embedded with hierarchies of power and advocates the need for new theoretical frameworks in child studies that can meet the demands of an unjust world. Moving between diverse scales and sites, such as art galleries, spaces of war, and critical engagements with film and literature, this project explores the queer temporality of development as it impacts children's imaginings and representations of the future. Thus, even while my study is centered on histories of colonial devastation, death of ancestors, homophobia, and geographies of war, I seek notice of the creative ways that children express themselves in the aftermath of traumatic experience. In celebrating the visual and aesthetic cultures of childhood, this project offers a way to think about children's urgent need for protection and care without suspending their agency under the guise of innocence.

Paying attention to how aesthetic expression satisfies the emotional needs of children and the need for the adult to feel-through childhood experiences, I locate this work in relation to psychoanalytic theory that claims aesthetic experience as a site to symbolize loss (Georgis 2013; Hagman 2005; Kofman 1998; Tarc 2015). Undertaking a project on children's art and art about childhood is not an attempt to escape from the urgency of contemporary inequalities. Rather, as Jose Muñoz clarified, aesthetics can "map future social relations" (2009, 1)

# INTRODUCTION 13

that are premised on kindness and empathy. Art, Munoz proposed, contains blueprints from future relations not yet realized (1). According to Edward Said, cultural production cannot be understood as "antiseptically quarantined from . . . worldly affiliations" (1993, xiv). Art, as a form of cultural production, cannot be discontinuous from inner life or social relations. Rather, it may be understood as an affective elaboration of the dilemmas of growing up. The interpretive context in which I study art by and about children resists positing new truths about children's psychosocial development because my theorizing does not make definitive proclamations about what children's art proves to adults but, rather, asks what is psychosocially and emotionally accomplished by its making. My challenge is to conjure theories of child development that help to recompose the field of child studies so that it can critically account for the asymmetries of innocence that cut along lines of inequality.

## Queer Affect, Aesthetic Expression, and Cultural Experience

One of the aims of this project is to develop theories of childhood development that are attentive to the implications of violence, trauma, and social alienation on children's ability to creatively express themselves. In the aesthetic archive of childhood that I compile, special attention is given to children whose gender, sexuality, race, and/or citizenship force them to struggle emotionally and socially. These children are a queer presence in their social worlds because their growth bears resistance to the myth of childhood innocence. Since the 1990s, queer theory has grappled with how essentialist

14 THE QUEER AESTHETICS OF CHILDHOOD

notions of identity foreclose and thus punish difference. In asking what is normal and how is normalcy socially constructed, queer theory has sought to undermine methods and models of societal exclusion based not only on gender and sexuality but also on race, disability, neurodiversity, and, in some cases, age. Outside of the narrative and biographical coherence required by LGBTQ identity, contemporary queer theory explores and honors disturbances to identity; the affects, social events, and feelings that turn us against ourselves and others so that we can grow. Queer theory's unique methodological capacity for critiquing normalcy is valuable in honoring children's creative resistances to convention, truth, and knowledge. From Sedgwick's (1991) discerning work on the proto-gay child to Stockton's (2009) and Halberstam's (2011) declarations that childhood is an essentially queer experience, theories of childhood have been made better by inclusion of queer theory's difficult questions concerning normalizing procedures that govern gender and sexuality. By giving language to the retrospective temporalities of childhood, constituted through the adult's glance backward toward their own biography, Stockton helped to inaugurate the field of queer child studies. *The Queer Child, or Growing Sideways in the Twentieth Century* (2009) was the first book-length manuscript to be written on the topic of the queer child. My work extends lines of thinking first developed by Stockton, who recalibrated schemas of growth from their linear hierarchies toward a rhizomatic and diffuse sideways growth. For her, potentiality and innocence, the definitive signifiers of childhood, make it a queer experience because it comes before mastery and reason. The more innocent we make children, she argues, the stranger they become. Unlike the normative idea of the child

whose future we must save, the queer child promises nothing but hints at contingent and provisional futures. The queer child haunts normative descriptions and temporal positionings of what it means to grow up.

Steven Bruhm and Natasha Hurley's anthology, *Curiouser: On the Queerness of Children*, appeared five years before Stockton's full-length book, and its introduction devotes a full page to describing how its authors and allies were threatened with censorship and surveillance for sexualizing children (2004, p. xxxiii). The sanctity of childhood innocence is threatened by the elicitation of knowledge about children's queer feelings; thinking childhood and queer at once continues to make some people very nervous. My work owes debt to those who have done so: the collective effort of their scholarship has helped to reform a space that is constituted by the intense discomfort of theorizing the tabooed subject of queer childhood. As queer theory presses harder on the rhetoric of childhood innocence, it has helped in making notice of its inherent exclusions for those children who illuminate potential reassemblages of gender and weaken categories of the dominant. Placed among this corpus of scholarly contributions, my study uses the concept of the queer aesthetics of childhood as a new category under which we might gather techniques for understanding how histories of inequality reappear in aesthetic experiences. Applying queer theory's rich history of studying nonnormative modes of being and belonging to the field of child studies, this book makes the case that the queer feelings that can't be educated out of children reappear in their aesthetic expressions. "Often we can glimpse the worlds proposed and promised by queerness in the realm of the aesthetic," Muñoz reminded us (2009). At

the same time, I offer a revision to queer theories of childhood by observing the agentic force of children's imaginings of the future as symbolized in their expressive cultures. What Jonathon Lear calls "the tough ethical and erotic conflicts involved in growing up and growing away" (2015, 71), find expression in art and creative play. That is, forbidden and hence hidden but not dissolved infantile wishes for safety and for all-encompassing love can be uniquely expressed in art.

Stockton describes how queer children spill sideways, making serpentine growths through metaphors and animations of delay ("my dog is my wife," "my dolly is my mommy," are some examples). Integral to her argument in *The Queer Child* is Jacques Derrida's notion of delay, which she describes as "the inescapable effect of our reading along a chain of words (in a sentence, for example), where meaning is delayed, deferred, exactly because we read in sequence, go forward in a sentence . . . while we must take the words we have passed with us as we go, making meaning wide and hung in suspense" (2009, 4). Stockton likens Derrida's theory of delay to the project of growing up; one should not arrive too quickly to adulthood and thus must be held in a series of deferrals until an adult self is revealed, like meaning in a sentence. The deferrals, departures, and resistant curiosities that are not extinguished with the act of growing up may be categorized as queer. With Stockton and most other queer theorists, I am not specifically equating queerness with LGBTQ identity, but using the term to study children who, while "hung in suspense," are involved in reimagining intimacy, loving, and futurity. I am not interested in assimilating all children into LGBTQ politics, but rather, use queer theory to strengthen child studies. The notion of queer childhood can disrupt

# INTRODUCTION

bourgeois modernity and its insistence on cultivating the nuclear family, can problematize assumptions of the child's heterosexual future, and can help to release the figure of the child from heteronormative and gender-normative theories of development. Queer childhood offers a conceptual terrain on which to propose an analytic suspension of the child's anticipated future in order to care for children in the present. *The Queer Aesthetics of Childhood* builds on the work done by queer theorists studying childhood by adding a psychoanalytic study of aesthetic experience and by exploring the material consequences of what Stockton terms as "sideways growth." Because so much of the literature on queer childhood comes from outside the field of child development (mostly, it is produced by literary theorists), my study uniquely offers an interdisciplinary approach.

My queer theory of childhood offers the possibility of both supporting children's imaginings of the future and being attentive to re-emergences of contracts and definitions of human worth made in capitalist modernity. Traces of these contracts and categories of the human recur in prevalent notions of childhood innocence and protection. This is alarmingly true for children of migrant and refugee families taken from their parents in the United States, as it is for Indigenous children, too often placed in state and foster care. Indeed, the practice of taking Indigenous children from their families is central to the building of the Canadian nation-state. Wilma King's crucial book, *Stolen Childhood: Slave Youth in Nineteenth-Century America*, documents an example of the differential treatment of children in the making of a nation. In the long history of racialized constructions of innocence in America, Trump's policies are not exceptionally new, though they are

horrific. Tera W. Hunter has pointed out that in the contemporary moment, "President Trump has repeatedly called young border crossers future criminals, with the seizure of children described as a national security measure that will prevent crime later. 'They look so innocent; they're not innocent,' Mr. Trump said in response to criticism of his policy."[2] The maintenance of borders and the construction of nation-states has long relied on discourses of childhood innocence to justify treating nonwhite children differently. My analysis of the cultural politics of childhood also draws on Erica Meiners, Rebekah Sheldon, and others who are working diligently to study the overlap between theoretical and material experiences of childhood. In *The Child to Come: Life after the Human Catastrophe*, Sheldon is interested in the use of the figure of the child for environmental politics. She deftly shows how the child-figure "informs the rhetorical figuration of future catastrophe" (6). Sheldon's work is an important ally to my own for its explorations of the political weight that the figure of the child carries. Paul Amar (2016), Ruth Nicole Brown (2014), Claudia Castañeda (2002), Aimee Meredith Cox (2015), Lisa Farley (2018), and Julian Gill-Peterson (2015, 2018) have also shown how young people's apparent diminished capacity for reason is proven otherwise in their negotiations of global politics, social injustice, and racial capitalism.

Amar, discussing children's revolutionary actions in Egypt, writes, "It would seem 'the infantilized' can only be a pernicious category designed to control various populations. So to take the next step, one may ask: Beyond these control functionalities does the child exist? Can the child persist as an unproblematic or natural category of the (sub)human after global machinations of infantilization have been revealed as

fundamentally dehumanizing? By what political expediencies do children remain ruled not as agents but as spectacles of compelling innocence, securitizing horror, and developmentalist dependence?" (2016, 571).

*The Queer Aesthetics of Childhood* helps to fill in the space left by these questions and to understand how what Mel Y. Chen terms "imperialist spatializations of 'here' and 'there'" (2012, 167) continue to appear in the field of child studies. I seek to refocus intentionally obscured connections between theories of child development, histories of nation-building, and contemporary debates about belonging. Caricatures of children as vacuous and innocent, representative of what should be preserved in the future, have helped to cement mythologies of the global north's benevolence and care for the global south (Briggs 2012; Castañeda 2002). Robin Bernstein's essential book *Racial Innocence: Performing American Childhood from Slavery to Civil Rights* (2011) analyzes how the rhetorical force of childhood innocence has strong sociopolitical consequences for children who aren't white in America. For Bernstein, the performative texture of childhood largely involves the racialization of innocence. Philippe Aries famously traced the history of the phenomenon of "innocence" and its place in Europe's cultural imaginary (1962). The Eurocentrism of his work lingers in the field of child studies, as his discussion of Europe's project of sentimentalizing childhood is often treated as universal and dismisses racial classifications constructed during colonial invasions. Ian Mosby's 2013 study of the intended impoverishment of children in settler-colonial spaces like Canada can work as an antidote to the tendency to universalize innocence. Adding to this growing body of literature, which places gender, sexuality, and race as central

to analysis, I provide a theory of development that coerces confrontation with the social construction of childhood as it is formed in, what Lisa Lowe terms, the "intimacies of four continents" (2015) and their racialized histories, geographies, and affects. The centrality of queer of color critique and transnational feminism to the development of my own thinking on the topic of childhood innocence insists upon addressing the emotional and political residues of colonial histories and settler colonial formations of nation-states.

As I have begun to suggest, *The Queer Aesthetics of Childhood* is also inspired by psychoanalytic and cultural studies scholars who demonstrate that a work of art should be studied for its ability to archive and explain the extradiscursive and extrajuridical properties of social life. A psychoanalytically informed perspective on children's art proposes that in creative expression they actively make sense of and gain control over loss, confusion, and grief. Reading psychoanalytic theories of psychological development alongside queer and feminist theory helps to question how childhood has been operant in discourses of what it means to be human. My use of psychoanalysis expresses itself very differently than Lee Edelman's reliance on Lacan's social imaginary, in what is perhaps the most controversial publication on queer culture and the uses of the Child (2004). Edelman understands queerness as death, and asks that we accede to the death drive, opting out of reproductive futurism in an antisocial embrace of the radical potential of undermining the ubiquitous "cult of the Child." Jonathon Lear explains that "for Freud, the death drive is an entropic tendency in every living organism—a tendency to fall apart" (2005, 163). Edelman believes that queer culture works on behalf of the death drive because of its resistance to

marriage, reproduction, and other heteronormative cultural norms. Such practices of refusal and alternative symbolic economies of meaning make queer culture, for Edelman, adhesive with the death drive's machinations. While influential to my thinking, the discontinuous temporalities that the queerness of childhood captures cannot be conjured within Edelman's framework. Because for Edelman, the child is a kind of "anti-queer" that provides justification for the reproduction of straight culture, his work faces a limit in the context of this project. In an effort to abstract the child he invokes from the weight of material experiences that might complicate his theorizing, Edelman (2004) capitalizes the Child to whom he refers in an effort to distinguish it from real, embodied children. I find this schematic useful, though not sustainable. On the one hand, there is the material child who calls upon the adult for support, and on the other there is the adult's idea of what childhood should entail. But, in agreement with Gabrielle Owen (2010), I do not believe that cultural constructions of childhood and conversations about actual children are ever really separate, though they often emerge from different disciplinary traditions (255).

Taking a different route through psychoanalytic literature, of particular interest to me are the psychic processes of identification, loss, splitting, transference, and affective attachment, as explained by Freud and reworked by Melanie Klein and D. W. Winnicott. In the service of developing *The Queer Aesthetics of Childhood*'s arguments, the psychoanalytic school of object relations, which premises the acquisition of subjectivity on a relationship to the Other, figures centrally. Object relations theory proposes that the infant's psyche develops "though interaction with, and internalization of,

## 22    THE QUEER AESTHETICS OF CHILDHOOD

significant others" (Brennan 2004, 33), and is thus useful in thinking about how children build attachments in the social world. Object relations theorists emphasize the child's struggle to adapt to a hostile world that can refuse to actualize their psychic wishes and desire for omnipotent control. An appreciation of what Freud deemed the irredeemable conflict between the child's instincts and the demands that culture places on the child, is vital to this inquiry. Complemented by postcolonial studies, feminist theory, and queer of color critique, I engage in discussions of how entanglements between sciences of childhood development and sciences of race have justified colonial and imperial interventions.

From its inception, psychoanalysis has understood the formation of psychic life in childhood as crucial to individuation and to an adult's capacity for relationality. At times I read psychoanalysis against itself, conceding its Eurocentric genealogies and related limitations and, also, recuperating its potential salience for description of the psychical attachments and fantasies that reverberate in social life. Psychoanalysis, as interpretive method, can connect cultural and psychical components of subject formation, as it understands that representation and affect are deeply conjoined. Because aesthetic experience, in psychoanalytic terms, is understood as an elaboration of infantile experiences and our first affective attachments, childhood is inextricable from creative processes. The negative affects of childhood experience may not wane until they are communed with and aesthetically elaborated. Encounters with art and the creation of drawings, novels, and film, for example, offer an aesthetic experience in which "disavowed affects of relationality: loss, conflict and pleasure" are expressed and held (Georgis 2013, 77). Where the development

of emotional life gets stuck, art can help. In art and cultural production, unconscious desires and demands find air. The aesthetic texts that I examine in this study are treated as useful for the openings they create into dialogue about the queer divergences of child development. Though I discuss how children's artworks might have their own unconscious life, operating as symptomatic disclosures of inner struggles, emphasis is also placed on the psychic function of creativity more generally. Child rights advocates and child psychologists have long suggested that art-based therapies offer children an opportunity to communicate and reflect upon difficult experiences, such as war, geopolitical conflict, forced migration, and cultural genocide. Presenting children with venues to aesthetically express themselves is a routinely used practice to archive, communicate, and disrupt the impacts of abuse and violence in childhood. Because children are in the process of constructing social and symbolic systems that will determine their responses to future conflict, offering a creative space for them to mourn and communicate the traumatic loss of home, family, or sense of safety is essential. In examining creative fictions about childhood and children's own creativity, this book furthers understanding of how and why cultural production can open the social environment to the emotional landscape of loss, grief, and pleasure. Cultural production by children and about childhood often discloses cultural anxieties about racialized and gendered embodiment, love and loss, and inheritances of historical trauma. Thus my psychoanalytic study of aesthetics is complemented by feminist theory, decolonizing theory, and literature in the field of settler-colonialism.

## The Child for Whom I Write

My associative belonging to this project is multifaceted. As an academic working in the field of child studies, I am invested in the growth and potential contributions of the discipline. This project is also, in part, an attempt to work through ambivalent feelings toward my experiences working in residential facilities (group homes and shelters) that temporarily house children and youth deemed "at risk." Prior to and concurrent with the early stages of my graduate work, I was employed as a Child and Youth Worker (and have more recently been employed to teach students in this field of study). Offering respite from violence (defined in various ways, including the violence of homelessness), inside the residential facilities where I worked, punitive measures of discipline and uncompromising responses to aggression and anger occurred alongside revolutionary circuits of care and devotions to alternative education. Many of the children and youth I was employed to support identified as LGBTQ, and a part of my role was to facilitate a confidential support group for them. While doing this work I began to notice how these children and youth's aggressions were often a cover for sadness made from a loss of belonging (especially for those who voluntarily left or were apprehended from homes deemed too violent to live in). Because so many of the children and youth who visit shelters and group homes have suffered from violence, it was also necessary to acquire an ability to detect symptoms of trauma.

While working in the field of child and youth care, I began to think about the cultural politics of childhood and the psychic wounds caused by discourses of childhood innocence. The structuring logic of innocence, which assumes the porous

buoyancy of childhood where young people are described as innately resilient, did not protect these children from the material or psychic hardships of injustice. The life-making capacities of innocence, which create financial and political value, were not granted to these children and youth. The overrepresentation of queer, trans, Black, Indigenous children, and children of color who moved through the shelters and group homes in which I worked demonstrates this to be true. They know the asymmetries of innocence well. My scholarship braids the tensions I felt doing this work, and my general ambivalence toward the project of assuming care for and "protecting" children and youth "at risk." The children and youth who move in and through homeless shelters are too often treated as expendable, not as future entrepreneurial subjects who will accrue capital or political value in the process of growing up. Further, neoliberal and conservative imperatives routinely neutralize any potential that child and youth shelters and group homes may have for creative responses to aggression, to homelessness, and to physical and sexual violence. Vexed by neoliberal policies that ask for proof of their successful treatment of systemic issues in order to secure funding, and funding bodies that request empirical demonstration of a likelihood of quantitatively fixing aggression and pain, the creative potential of these institutions is foreclosed. These organizations must then attempt to address the young people who access their services as capital in configuration, forced to imagine entrepreneurial and industrial skills as opportunity for individual and national repair while suggesting that these skills can alter, in already knowable ways, the trajectory of their participants' lives. Of course, this logic hinges on measurable cures for individual aggression

26    THE QUEER AESTHETICS OF CHILDHOOD

that suppress and elide the collective violence of poverty. The residential facilities in which I worked add flesh to Lee Edelman's polemic, *No Future: Queer Theory and the Death Drive* (2004), a text I return to regularly to make sense of how it is possible to entwine a child who might be found in such an institution with the Child he summons.

Another theme of associative belonging, and deeply related to the foregoing, is that this text offers a way to think about the damage waged against those who grow up queer in a culture that cannot, though it sometimes tries, sufficiently support such growth. In a time when representation of LGBTQ children and youth proliferates in media and popular culture, it is important to notice the continued homophobia and transphobia (sometimes blatant and sometimes shrouded behind good intentions) that impacts children's subject formation and affective attachments. As queer theory presses harder on the rhetoric of childhood innocence, it has helped in making notice of its inherent exclusions and its consequences for LGBTQ people. John Nguyet Erni (1998) categorizes the queer body as an "adventure in surplus representations" (160–161). Queer childhood might be conceptualized as the surpluses that can't be explained or contained by developmental theory. My queer theory of childhood aims to illuminate how heteronormative and gender-normative developmental theories can make queerness intolerable. When queer desire and subjectivities are repressed, their expression requires a large amount of creativity and fantasy because they are shrouded in shame. Therefore, I use the rubric of queerness as a means to reference the child's capacity for creative reinterpretations of kinship, belonging, and pedagogy. The children and childhoods that are interpreted here also depict varied examples

of how gender presentation is determined by a complex network of libidinal ties, conscious desires, and not always conscious but deeply felt phantasies.

A significant moment in my personal life also informs my theorizing and writing: I am now the parent of a child. This has been a reminder of the humility and patience needed to be with the child's curiosity. It has also offered a greater understanding of what Freud deemed the irredeemable conflict between instincts and the demands of cultural life. Beyond spending the past months observing and being the recipient of my child's instinctual loving, I have also accumulated a host of experiences with the inadequacies of heteronormative models of parenting and child raising. My child has two mothers, and echoed in his development and its attending narratives will be my experiences with homophobia and heteronormativity. Indeed, these will also be his experiences as he finds an emotional place within a heteronormative world. Despite legal recognition of our family configuration, the psychopolitical conditions of sexual liberation are fraught for queer families. To be a queer parent is not an identity that elides what Alice Pitt and Deborah Britzman call "difficult knowledge" (2003). My son will experience a queer childhood because it digresses from what is typically described as normative domestic origins. I hope this project provides a way to think about and support the many children's lives that are constrained by theories of development that assume parentage to be heterosexual. This project, at times, has provided a space to theorize my own queer subjectivity and role as a queer parent to a young child in a world saturated with heteronormativity. Curative to my anguished worries about my son's future has been a stream of family portraits drawn by

my young niece and nephew, which happily depict our family. In their eight- and ten-year-old aesthetic expressions of my family, they depict my partner, myself, and our child with ease. The reparative potential of their art has been deeply important to my study of queer childhood and a reminder of the hope found in children's art.

## Chapter Outlines

Turning to images of childhood rendered in cultural production, each of *The Queer Aesthetics of Childhood*'s chapters reckons with how we, as adults, can let our theories of childhood development be affected by children's queer imaginaries. Each chapter stages a critical encounter with the visual cultures of childhood, engaging a range of social debates about the child's relationship to and possession of queer feelings. Taken together, the chapters form an aesthetic archive from which to theorize the relationship of difficult childhood experience to creative expression. In making connections between seemingly disparate phenomena and events (war in Gaza, a film about British nationalism and boyhood, debates about sex education, the scene of reading and encountering art), I seek to show their affective and political resonances.

The first chapter, "Queer Temporality in the Playroom: Ebony G. Patterson's and Jonathon Hobin's Aesthetics of Child Development," theorizes the queerness of child's play and its relationship to racialized distributions of childhood innocence. This chapter considers how Hobin and Patterson, two artists, represent and reinvent childhood. The repeated injunction that children play innocently and without political nuances is contested in both artists' work. This chapter

INTRODUCTION 29

situates one of Patterson's installations and a series of Hobin's photographs within a discussion of play's ability to render known the interior world of a child. Whereas Patterson's aim is to remind her viewer that Black children are deserving of the protective hold of sentimentality, Hobin insists that children's agency is inhibited by assertions of innocence. Neither, though, believes that children escape the abjected traces of violence left on their subjectivity after being born into an unjust world, despite the promise of innocence. My study of their art turns to the work of Melanie Klein, who first elaborated a theory of children's play as a conduit for their affective impulses. In Klein's clinical practice with children I find explanation of how the emotional work done in play increases the ability to be recognized as an individual with agency. In the act of play, a queer temporality can be summoned where time moves differently and revisions to injustice can be made.

The second chapter, "Art and the Refusal of Empathy in *A Child's View from Gaza*," considers the phenomenological status of a childhood or adolescence lived "at risk," specifically at risk of war. Extending my conceptualization of art about childhood as a conduit of new interpretive possibilities, I offer a critical reading of the book *A Child's View from Gaza: Palestinian Children's Art and the Fight against Censorship*. Published in 2012, with a foreword by Alice Walker, the book features forty-four drawings by Palestinian children who experienced war during Israel's 2009 invasion of Gaza. *A Child's View from Gaza* demonstrates that the psychic wounds of war and settler-colonialism are expressed in Palestinian children's art. The drawings were originally intended to be publicly exhibited at the Museum of Children's Art (MOCHA) in Oakland,

## 30 THE QUEER AESTHETICS OF CHILDHOOD

California. After heated debate, it was decided that the art was too graphic for children to witness and that the show would be canceled. Under pressure from community groups and a host of individuals, the museum concluded that the children's drawings, which explicitly rendered visible some of the psychic and social costs of war, would cause discomfort in a space regularly constituted by the doctrines of childhood innocence. The queer affects of these childhoods were attempted to be disavowed so that perceptions of innocence remained steady in the children's museum. Offering inquiry into the social construction of childhood innocence in a transnational and biopolitical frame, I consider how and why it could be decided that art made by Gazan children did not serve children.

In chapter 3, "The Queer Remains of Childhood Trauma: Notes on *A Little Life*," I offer a critical reading of Hanya Yanagihara's 2015 novel, *A Little Life*. Yanagihara's narrative offers a revision of the tendency to emphasize children's inherent resilience and plasticity, which assumes in-born capacities to get over difficult experiences. The novel tells the story of a queer man whose childhood involved a series of traumas, and then whose adulthood experiences are connective to these early events. The protagonist in *A Little Life* cannot get over his history and thus offers a case study in the queer adhesion between difficult experience and adult subjectivity. The novel, an aesthetic text that elaborates the queer union between difficult childhood experience and adult subjectivity, cautions against efforts to immediately get over loss, preferring to pause and consider its remainders. Yanagihara's beautiful unhinging of time helps the reader to understand and to be affected by trauma's temporal causalities.

The fourth chapter, "Reparation for a Violent Boyhood in *This Is England*," continues to ask what can happen when a child doesn't effectively mourn loss. In this chapter I offer a critical reading of Meadows's 2006 film. *This Is England* calls attention to the trauma of losing a parent, the residual state of grief made from this loss, and the value of mourning. Further, as white nationalisms and violent insistences on the denigration of immigrants continue to propel England into conflict, the film offers a powerful statement on the psychic life of racism. In narrating a child's psychic interiority after the death of a father lost to war, Meadows cautions against what can happen to development when the expression of grief and rage is inhibited. An invitation into the emotional space of a young life altered after the traumatic loss of a parent and the affectivities of grief obfuscated by a feigning of confidence, Meadows's narrative suggests that violent masculinity can result from the repression of vulnerability. His narrative also suggests that affective attachments to racist nationalisms are, in part, psychic strategies that foreclose the ability to mourn. My reading of the film is interested in the narrative's relationship between injured masculinities and men that injure. Thus this chapter offers new ways to think about the psychosocial development of masculinity in boyhood. This chapter also delves into questions of pedagogy as I consider viewing the film as a curricular assignment given to students in the field of child studies.

Then, by way of a conclusion, I enter a contemporary debate about childhood innocence that takes issue with sex education. I make a conceptual shift away from polarizing debates between those who encourage children to identify with LGBTQ identities and those who insist the child is too

"innocent" to do so. In a moment where children are increasingly identifying themselves as LGBTQ, this debate often plays out in discussions about the contents and age appropriateness of sex education. No matter one's opinion on the topic of children's sexuality, it will be made from the traces of our own experience of learning about desire. The adult's rationality, maturity, and knowledge depend on what is made of "the child." Working against the encasement of the child in a paradigm of innocence that functions to mask the projections we consign to them, I inquire into the emotional scene of teaching and learning about sexuality with children by engaging with Chase Joynt's short film, *Genderize.*

As queer theory presses harder on the rhetoric of childhood innocence, it has helped in making notice of its inherent exclusions and consequences for LGBTQ people. *The Queer Aesthetics of Childhood* builds on this work by adding a psychoanalytically informed study of aesthetics and by exploring the material consequences of sideways growth (Stockton 2009) from within the discipline of child studies. For the child, a wider affective range and intense emotional expression are expected. In growing up, the freedom of affect becomes restricted as the culture's norms restrict expression and desire. The feelings and experiences that resist the prohibitive restraints of development endanger the ambitions of morality and culture. Thus they may be termed "queer." Thinking of queerness in this way helps to meditate on childhood's creative and enigmatic reimaginings of the representational field of social life. My study of the cultural politics of childhood is committed to understanding how the asymmetries of innocence, fraught with dependencies on hierarchy and inequality, can be repaired through aesthetic and artistic

expression. A major goal of this work is to show how the blending of methodological and epistemological concerns from queer theory and child studies can help to resist approaching children and their childhoods as a magnet for transference of our own adult anxieties and narcissistic wounds so that we may care for their alterity and difference. As the field of knowledge and practice in critical child studies grows, how can the theorizing of childhood emerge as crucial to questions of social justice? The arguments made here are not inclined to reverse the field's priorities but to flesh out the affective and embodied nuances of living the life of a child. *The Queer Aesthetics of Childhood* advocates the need for new theoretical frameworks in child studies that can meet the demands of the contemporary moment, engendering a different relation between children and the adult world to which they must respond.

# 1

# Queer Temporality in the Playroom

## Ebony G. Patterson's and Jonathon Hobin's Aesthetics of Child Development

An ellipsis is a sentence I don't end because . . . you know what I mean.

An ellipsis is a figure of return that isn't symmetrical.

Ellipses might be a figure of loss or plenitude: Sometimes it is more efficient to go dot dot dot. Sometimes it's also a way of signaling an elision. Sometimes the referent is beyond words.

—Lauren Berlant (*Artforum* 2014)

On June 25, 2016, I visited Ebony G. Patterson's installation . . . *when they grow up* . . . at Studio Museum in Harlem, New York—as social media reminded me that morning, on the same day Tamir Rice would have turned fourteen. Rice, a twelve-year-old, was killed by Cleveland police when his toy gun was mistaken for a real one. Patterson's installation, a plush, pink carpeted room with mixed-media representations of Black children and childhoods, criticized the killing of Rice and other children whose racialization fatally forecloses

## QUEER TEMPORALITY IN THE PLAYROOM    35

assumptions of their innocence. Moving through the installation was a powerful experience that coerced confrontation with the social construction of childhood and its racialized histories, geographies, and affectivities. On the floor of the gallery, Patterson had laid toy guns bedazzled with sparkles and buttons, an intended reminder of Rice's choice of play object. An aesthetic engagement with Black lives left out of the future, ... *when they grow up* ... invited an audience to build an ethical relation to children by emphasizing the value of their play. The installation provoked profound questions about the meaning of childhood, but also the social responsibility to care for children. In her title, Patterson's use of ellipses in the spaces where a past and a future should be lived raises questions about how and why some children must bear the burden of the limits of innocence.

The gallery's didactic for the installation stated that "the artist uses an immersive viewer experience to question the systemic inability to see black children as innocent and vulnerable." Tamir Rice's and Aiyanna Stanley-Jones's deaths, both cited as inspiration for Patterson's work, pronounce an asymmetry in the state's application of innocence and sentimentality to childhoods. Stanley-Jones was seven years old when she was killed during a police raid in Detroit, Michigan. Ebony G. Patterson's playroom invited an audience to mourn these children, but also to participate in imagining a future in which the affective losses and political strife that result from the racialized asymmetry of childhood innocence are reckoned with. Patterson's creation of a playspace in which children can rework and reinhabit the future, and her centering of play as a reparative practice, are reminiscent of Jonathon Hobin's "In the Playroom." In Hobin's 2010 series of

36     THE QUEER AESTHETICS OF CHILDHOOD

portraits of children, the Canadian photographer also invited spectators to peer into playspaces to reflect on the sociopolitical conflicts that shape individual children's development. "In the Playroom" cast children as actors in scenes of geopolitical conflict in order to provoke recognition of how hostile social relations make their way into children's play. Staged in spaces traditionally understood to house children's play, such as bedrooms, bathtubs, a kitchen floor, and a playground, Hobin's child subjects are photographed in "tableau-vivant re-enactments of the very current events that adults might wish to keep out of their child's world."[1] Scenes recalling Hurricane Katrina, the falling of the Twin Towers on 9/11, the torture of prisoners in Abu Ghraib, and the aftermath of Hurricane Katrina, for example, recast solely with children, provoke consideration of the child's relationship to political crises. In the series, Hobin claims children's play as political events in which "they explore things that they hear or see, whether or not they completely understand the magnitude of the event or the implications of their play" (ibid.). Hobin's photographs critique discourses of innocence so that adults might take better notice of how knowledge of global issues, such as war, environmental damage, and racism, leaves traces on children's understanding of themselves and others.

Though very differently, both Patterson and Hobin have created art that causes a disruption to the epistemological, affective, and social formations of childhood innocence. Both artists activate an aesthetic form of critique that destabilizes dominant theories of childhood and their related temporalities. The playrooms they create have a psychosocial, as much as a spatial, dynamic, in which the artists insist that the biopolitical management of life and death is not only related

to but deeply entangled with the rhetoric of childhood innocence. Whereas Patterson's aim is to remind her viewer that Black children are deserving of the protective hold of innocence, Hobin insists that children's agency is inhibited by assertions of innocence. The exhibitions, taken together, offer a productive site for considering the representability of what is accomplished in child's play. The playroom becomes the material terrain on which questions about how social life comes to bear on the child's psychological interiority are elaborated. While showing how the trope of innocence is both a temporal and an epistemological regime that regulates the symbolic meaning of childhood, Hobin and Patterson each insist that powerful resistances and reparations can occur in child's play. Both artists represent a haunting negativity and queer temporality in the playroom, a space traditionally meant to induce joy and simplicity. Differently, they ask their spectator to take on the task of reworking theories of childhood development so that we notice both the ontological and the psychical textures of "growing up" as it is propelled and restrained by the coercive force of childhood innocence. While acknowledging their divergent theses and aesthetic approaches to children's play, this chapter considers the work of both artists for its ability to cause reexamination of the rhetoric of childhood innocence and its related forms of violence. Considered together their art helps us to engage with and become alert to some of the adult fantasies that construe "normal" child development.

I turn to Hobin's and Patterson's aesthetic expressions of childhood to ask: What is the affective texture and temporal pulse of the child's play? What is gratified, expressed, and psychically repaired in their play? In the interest of achieving

a new form of relationality between children and adults where hierarchy is loosened, I theorize play as a mode of future-making in which the developmental itineraries of childhood are released from the pressures of "innocence." Both Hobin and Patterson highlight the significance of inviting adults into a playspace in order to increase their capacity for empathy. In their work, play becomes a queer practice of repair, a therapeutic activity in which reunions with emotions that must be vanished for the purposes of maintaining the veneer of innocence over childhood become possible. Because their theses about innocence are distinct from each other, reading Hobin's and Patterson's aesthetic protests against sentimentalizing childhood beside one another inspires insight into the complexity of children's play. Their art becomes an affective medium with which to confront investments in the child's presumed innocence or, in the case of Patterson's installation, the nonwhite child as a perilous threat to public welfare. Being invited into the space of children's play is an ethical invitation to be with children as they grow into a world not of their making but, nonetheless, one to which they must belong.

To be sure, developmental ideals concerning the child's growth sustain and produce hierarchy along the lines of race, class, disability, and sexuality.[2] Despite suggestions that all children are born innocent, developmental theory's entrenchment in liberal capitalism and history of alignment with sciences of race and categorization of humans means, paradoxically, that some children's access to the privileges of innocence is restricted. For example, the abstract promise of innocence did not protect Tamir Rice. My critique does not aim to reinstate innocence as a desired qualifier of appropriate childhood development but to consider what innocence

seeks to repress, which may be termed queer. Queer has been explained as that which exceeds normalcy. Queerness, as queer theory has long posited, is that which is abjected from normalization; it is subjectivity's excess of affect, memory, and desire. Queer, then, is innocence's other and can be used to describe that which remains outside of the symbolic authority of childhood innocence. Without material reference, always contingent (Butler 1993), queer can be used to name the socially disparaged desires (Georgis 2013) and affective reservoirs of hope, hate, and reparation that survive beyond the psychic and social demands of innocence. In the playroom, children can play with the queerness of their subjectivity. They can express that which persists beyond pressures to adapt to normalcy and eludes symbolic inscription and identity. In reorienting their spectator to the negative affects and ambivalences that underwrite childhood innocence, both Patterson and Hobin offer an encounter with the queerness of childhood. Thus, in my response to their aesthetic protests against innocence and its rhetorical vicissitudes, I spend time reading their work for the queer temporalities they expose and position the child within.

In play, a queer temporal plane is created, where time moves differently and the past is recuperated for its ability to clarify the present. To consider the value of play and its symbolic purposes, I turn to the work of Melanie Klein and D. W. Winnicott, both child analysts. I draw on Klein's theories of play in order to critique the symbolic economies and sentimental attachments to children's innocence that both procure imaginings of futurity and allow the adult's own past to be repressed. To this end, I employ a Kleinian, object relations theory of play. In *Playing and Reality* (1971, 2005) Winnicott

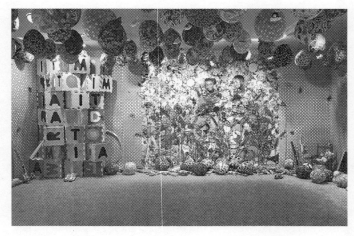

**FIGURE 1** Installation view, Ebony G. Patterson's ... *when they grow up* .... Courtesy of the artist and Monique Meloche Gallery, Chicago.

reflects on the role of children's creative pursuits in their development, describing how in play the child practices symbolizing inner turmoil for the outside world. Winnicott's insistence on the importance of the child's play helps to theorize the symbolic inscriptions and affective energies unleashed and operationalized in the child's playspace. Read together, Klein and Winnicott explain how the act of playing can alter affective capacities for reparation. I begin with engagement of Klein's theory of reparation in order to devise a way of reading both artists' work that gives primacy to the sociopolitical potential of children's play. I then theorize Patterson's use of ellipses in her title to consider the queer temporality of childhood development. My hope is to help in making a conceptual adjustment to assumptions of children's innocence by suggesting more attention be paid to the quotidian eruptions of trauma and violence's afterlife as it is symbolized in play.

## QUEER TEMPORALITY IN THE PLAYROOM   41

A desire to understand the affective and psychosocial dimensions of the child's space of play first leads me toward engagement with psychoanalytic theories of children's creativity.

### Object Relations and Aesthetic Repair

In providing children with a space for play and inviting adult witnesses into that place, both Hobin and Patterson aim to represent children's complex agency. The psychoanalytic field of object relations provides some explanation of the psychic structure of aggression, guilt, and desire that is at work in children's play. Melanie Klein, the child psychoanalyst, understood the child's play as an effort to symbolize unconscious wishes, conflicts, and libidinal urges. Because children are learning to use words to communicate feelings, they cannot free associate with the use of language in the way that Sigmund Freud's psychoanalytic practice of "the talking cure" required. So Klein turned to the child's play as a form of expression. Klein's theory of psychic development explains that in observing the child's play and games she was able to find the following:

> As regards to the depth and scope of the analysis, we may expect as much from children as from adults. And still more, in the analysis of children we can go back to experiences and fixations which in adults we can only reconstruct, while in children they are directly represented. . . . In their play children symbolically represent phantasies, wishes and experiences. Here they are employing the same language, the same archaic, phylogenetically acquired mode of expression as we are familiar in dreams. (1975, 135)

42    THE QUEER AESTHETICS OF CHILDHOOD

The child's play, for Klein, is a "discharge of phantasy" (1975, 199), in which the child tests out how the external world will receive their hopes and aggressions. The infant's psychic activity finds symbol formation in play, and the emotional work done in their creative expression acts as a precursor for the adult's ability to work through conflict. For example, in play, the child may encounter a lost object so that its loss is remembered in a deeply somatic and psychic way. Or, as Klein explains, through creative expression the child might learn to "help to put right" people and things who have been "harmed or destroyed" (Klein and Riviere 1964, 65–66). Interested in promoting "the emotional situation of the baby" (58) as an integral site of inquiry for the future of psychoanalytic practice, Klein observed that very early on, children's psychic lives were characterized by tensions between the affects of love and hate, or "good" and "bad" objects. These tensions begin with their attitude toward their mother. Klein's theory of infantile development proposes that babies should lose an idealized image of their mother. To do so, they must internalize their mother's nourishing qualities *and* her frustrating refusals to abide by their every demand. In phantasy, the infant fragments the mother, splitting her into an object that either satisfies desires or frustrates them. When she frustrates, the child physically harms the image of the mother. Then the child must put the mother back together again, so to speak, recognizing that she is both good and bad, nourishing and frustrating. In phantasy, the infant fragments the mother into part objects and the capacity to ethically address another comes from learning to restore this fragmentation and produce a synthesized mother. The child's reparative tendency is not developmental teleology but a constant negotiation between love and

hate, a negotiation that the adult continues to feel compelled to work through.

The child's phantasies, acted out in play, are "of a curative nature" (71). Their play, as understood by Klein, is a mode of managing the hard work of maintaining ambivalence and not sharply splitting the world around them into "good" and "bad." In observing and theorizing children at play, Klein was able to watch their fantasy life rise to the surface, enabling her to draw conclusions about the early impact of love, aggression, and guilt on the child's development. She built a theory of child's play that explains how the child's instinctual impulse creates a fantasy world where the child can assuage anxiety and worry. For Klein, the work of creativity in both play and art helps the child to recover from a propensity to wish damage on a loved object. In her conceptualizations, the libidinal economy of play is driven by efforts to repair what has been damaged in fantasy. What is worked through in the playspace, symbolically, unconsciously, and consciously, is the reconciliation between aggression and tenderness, anger and empathy. It is important to note that Klein does not flatten out children's play as straightforward repetition of what they have experienced. For her, there is not only historical fidelity in the act of play but also repetition with a difference that offers a horizon for new planes of thought. In fantasy-building, "fresh elements" (Klein and Riviere 1964, 89) are added to their realm of experience. The repetition that occurs in children's play does not necessarily manage compulsion but can also be an occasioning of newness in which tradition breaks open to allow new understanding to be made. Play is a way to work through experience and to insert newness into a chain of losses and restrictions that propels development. Play does not

simply freeze time or cement narrative but can reorganize chains of events so that a nonsequential understanding of time is made possible. That is, play can create a temporal misalignment that offers the child understanding, relief, and creative license by imaging relationships between objects and events that were previously not possible. Play provides an opportunity to externalize their emotional terrain, steeped in tendencies for splitting and repetition, but also streaked with creative impulses.

In espousing the primacy of hate in infantile fantasies, Klein offered an early critique of the rhetoric of childhood innocence by insisting that children can be wrathful and aggressive as much as good natured. As Doane and Hodges point out in their feminist critique of psychoanalysis, "Klein's infant is anything but sentimental construction" (1992, 19). A clutch of good feelings—empathy, sentimentality, nurturance—is generally expected when engaging with children and childhood. But in object relations theory, and Kleinian theory particularly, the adult's relationship to the child (and vice versa) is full of ambivalence, resent, and guilt. The internal impressions and pressures that arise from the primary emotions of love and hate travel into and out of the playroom, both spatialized and made mobile by play's occasioning of an encounter with what can't be assimilated. That is, play holds open space for the unfinished meanings and undesirable knowledge that form what might be termed the queer contents of development.

Klein's emphasis on the child's creative and symbolic labor helps to situate the playspace as vital to development (1955, 1987, 35). D. W. Winnicott, pediatrician and child analyst, also studied the emotional labor accomplished in

children's play. When observing children at play, Klein and Winnicott each became attuned to the psychical and emotional imprints left on creative expression. For Winnicott, the work of creativity is foundational to human existence, and like other psychoanalytically minded theorists of aesthetic expression, he understood creative impulses to be grounded in infancy and the concealed impressions left by early experiences with objects that resist our demands. Though a self-proclaimed Freudian, Winnicott's theory of aesthetics is a departure from Freud in that is does not claim aesthetic beauty to be a matter of the artist's talent but, rather, a result of the human impulse to create. In play, as a form of creativity, Winnicott believed that infants and children expose that they have "built up something in [them]self that could be called material for play, an inner world of imaginative liveliness, which the playing expresses" (1987, 79). Winnicott was interested in children's first engagements with objects, such as blankets, toys, pieces of fabric, even their thumbs, and how they gave psychic life to these objects. Though inanimate, these things become invested with phantasy and operative in the child's inner world. Winnicott called these things "transitional objects"; the infant both creates these objects, he explained, and culture offers them. He wrote: "The transitional objects and transitional phenomena belong to the realm of illusion which is at the basis of initiation of experience" (1953, 97). Winnicott observed that children use transitional objects, such as toys, to test out separation and individuation from the caregiver as they learn to be a "self" in a world shared with other people. Winnicott's strain of psychoanalytic theorizing about children's play is redolent with respect to the value it places on illusion and fantasy. Adam

46    THE QUEER AESTHETICS OF CHILDHOOD

Phillips suggests that for both Klein and Winnicott "early development was literally creative—the infant creating out of desire the mother who is ready to be found" (2007, 102).

Winnicott believed that the child's sensory modalities, creative tendencies, and psychological development required access to play. In *Playing and Reality* (1971, 2005), where his "theoretical statement on playing" is published, he advised that it offers a form of experience "to which inner reality and external life can contribute" (3). In his treatise on creativity, he suggests that play serves the purpose of self-revelation (146). Elsewhere he writes, "For the little child we allow a wider area than we allow for ourselves in which imagination plays a dominant role, so that playing makes use of the world, and yet retains all the intensity of the dream, is considered characteristic of the life of children" (1987, 171). From both Klein and Winnicott we can bolster understanding of how play helps children restore their environment to a space of safety and repair, if at least in the space of fantasy, but potentially, in social relations.[3] Play helps to fuse destructive and loving instincts and offers the child a sense of agency. In the playspace, the child can be more than a compliant repository for the adult's decisions and ideological persuasions. Indeed, in play children activate and petition agency. For Ebony G. Patterson, creating a venue for Black children to play may be an ethical mode of being with their creativity, and of helping them to make sense of the political circumstances of their ancestry and the social relations it causes in their present. Katherine McKittrick, referencing Frantz Fanon, writes, "'I entered the lists'—to notice how one is not just passively listed, but that one experientially enters into data as well; this repetition is

coupled with a mash-up, the pushing and running together of a number of quotations and ideas" (Hudson, 2014, 233). In Patterson's playroom, children may enter data and archives differently, and place an ethical demand on their spectator to provide care for their childhood.

The affective charge of play, much like the creative labor of drawing, offers the child a therapeutic activity. In the active labor of these creative activities, children demand their own epistemological and ontological saliency. In studying drawings made by children who witnessed violence in Darfur, Lisa Farley and Aparna Tarc (2014) suggest that somewhere between the child's creative expression and the adult's empathic witnessing, we might locate justice. Farley and Tarc theorize the children's drawings as emotional resources for working through[4] and making meaning from trauma. They suggest that the adult's empathic interpretation of "this unspoken form of knowledge renews for the child a narrative of a future beyond the silent repetition of a painful past" (2014, 841). They point out, though, that the adult's interpretation of the child's visual vocabulary of war is, of course, deeply affected by notions of the child's innocence and thus well equipped for the work of countertransference. Countertransference, in psychoanalytic thinking, describes the emotional entanglement analysts feel with their clients and the possibility to project personal feelings onto them. Because so much of adulthood is a reaction to our childhood experiences, the likelihood for projection onto children is high, but notions of innocence elevate its probability because the child's agency and alterity are disregarded. Working against impulses for countertransference, ethical witnessing of children's play and drawings can enable notice of how

they express unmetabolized experience and unconscious memories.

As this book has already argued, toward multiple social and psychic ends, children's presumed innocence casts onto them intergenerational debts that relate to the making of race and racism within global and regional imaginaries. In inviting adults into children's playspaces, both Hobin and Patterson are engaging with issues and problems related to the question of how the adults' tendency to transfer their own desires and politics onto the child secures or threatens children's ability to build a history and a future that satisfies their own desires. When childhood is mired in rhetorics of innocence and sentimentality, a passivity is assumed that needs to be abolished in order to witness the child's dynamic engagement with difficult knowledge. For the children who are not solicited to inflect the future with hope, the coercive force of innocence offers a different problem. In *The Melancholia of Race: Psychoanalysis, Assimilation, and Hidden Grief* (2001), Anne Anlin Cheng considers the psychic magnitude of the child's negotiations with the racialized fissures buried underneath but also tangibly obvious in the building of the American nation. She writes, "There are still deep-seated, intangible, psychical complications for people living within a ruling episteme that privileges that which they can never be" (7).

For the child who is not white or for other reasons not protected by innocence, the space of play can offer an opportunity to engage with and work through the lost and persistent archives of nation-building and the contemporary life of trauma born from racism. In her consideration of Jonathon Hobin's aesthetic intervention into the psychogeographies of playspaces, Lisa Farley uses Freud's supposition that within

the child's play there is an element of the uncanny at work (2014). Farley emphasizes the creative labor involved in play, suggesting that it allows both children and adults to "transform old material into new combinations of meaning" (17). Drawing on Winnicott, she offers playing "as a metaphor to think about the internal processes needed to make meaning from the electrified emotional content carried on the current of the uncanny" (17). In play, she explains, the uncanny return of repressed material can be aired as the found materials of past experience are worked through and digested.

Hobin's series of photographs has incited heated debate, to which Farley turns our attention. Some have taken issue with his transgression of the sanctity of childhood innocence and its exposure of the child's active knowledge of a violent world. Farley suggests that "the debate over the material children of Hobin's photographs is symptomatic perhaps of a larger question of what it can mean to invite children into a world and into a future that feels ruined already" (16). Her reading of the photographs emphasizes their ability to rouse a repressed history in the adult: "The affective punch of Hobin's images has less to do with their positioning of the child in unfamiliar scenes of violence and more with the way in which the photos agitate something in the adult" (16). *In the Playroom*, as Farley reads it, proposes that the adult's trope of childhood innocence is also a phantasmic relationship to their own history of development. That is, the adult's own history of failure, growth, repression, and reparation is uncannily returned in the artist's figural positioning of children. In his photographs, Hobin chooses child-doubles to play the role of adults who cause and suffer from violence. His referential impulse, in which the adult's political conflict finds new

meaning in the child's repetition of events, sets out to interrogate the relationship between childhood innocence and the adult's violence. Farley expresses this well in her proposition that, "each of Hobin's doubles also carries a perceptible sense of the adult's tendency to freeze the future in the emblem of the child. Playing with the trope of repetition, Hobin captures on film the adult tendency to defend against death, ironically by destroying the child's future" (19).

Ebony G. Patterson's investment is different, as is what can be said about her installation's relationship to childhood innocence. Hers is an invitation to the adult spectator to enter the child's playspace in order to build an empathic relationship with children too often denied a future. She offers an aesthetic experience in which to confront the racial imaginings that underwrite rhetorics of sentimentality and innocence (and their material practices). Concern for the violences brought upon children who hint at becoming something other than the culture's ideal inspires Patterson to represent the discontinuities and reversals of innocence. In appealing to the power of play to increase the prospect of empathy, Patterson demonstrates the underbelly of innocence; between adults and children identifications can also be made from disgust, resentment, sympathy, and hate. Dumas and Nelson point out that surveillance is often heightened "over and above" Black boys' "creative exploration of themselves and their social worlds" (2016, 33). Patterson offers a playspace for such creative exploration. Her installation suggests that the psychical process of identification is racialized and reveals a profound ambivalence toward some children that is energetically disavowed by sentimental constructions of universal innocence.

# QUEER TEMPORALITY IN THE PLAYROOM        51

Thinking about Hobin's photographs alongside Patterson's installation means that we must also consider the racialized asymmetry that children have to an innocent futurity that can defend against death. As Farley points out, "each of Hobin's doubles also carries a perceptible sense of the adult's tendency to freeze the future in the emblem of the child" (2014, 19). Hobin's children are frozen in time in order to appease the adult's needs, but Patterson shows how Tamir Rice, Aiyanna Stanley-Jones, and Trayvon Martin (each described by the artist as inspiration) were ascribed qualities that operate as an accelerant in the process of growing up. Christina Sharpe may characterize these children as living and dying in "the wake," a term she uses to describe the hauntological nature of slavery that continues to normalize Black death (2016). Childhood gains its symbolic power for its ability to stand in for the future the adult desires, but the childhoods Patterson is concerned with do not defend against death. Innocence, generally, holds children captive to the adult's power, but for Patterson, innocence is a better alternative than material death. That is, her concern is with child fatalities who might have been saved by innocence. The sentimentality and sacrilization afforded through childhood innocence might, she implies, save lives. To be addressed as naturally inchoate may, in this sense, be a safeguard against death.

In creating a space for play, Patterson aspires to return value to her child subjects' lives and demand thought about their futures. Patterson's hope to "represent black children as just children, with the same sense of curiosity, play, books, games as white children" is an insistence that some childhoods are overburdened by structural inequalities and attendant phantasmic formations (Pollack, 2016). Racism

creates a pressure to assert innocence in the face of danger. Farley credits Hobin for revealing the "adult's profound ambivalence toward the child, whose promise of a future is a fearful reminder of the radical discontinuity of time and existence—our unthinkable mortality" (2014, 17). On this point, Patterson's project departs considerably from Hobin's. Her desire to aesthetically represent the relationship between Black childhoods and premature mortality, a nascent possibility that there will be no future, highlights certain privileges proffered through innocence. Time, then, operates and accumulates differently for the child subjects in Patterson and Hobin's playspaces due to their divergent ways of addressing of childhood innocence and children's relationships to the future. Patterson restores an environment for mourning, play, and reparation, while projecting a new theory of time that can help us to be with her child subjects as they learn to trust a failing world. In the next section I theorize queer temporality as it relates to tendencies to distend, restrict, foreclose, and protect the child's future.

## What Is Encrypted in Innocence?

With its bright colors and lively patterns, Patterson's immersive installation is meant to "create a particular sense of innocence that contradicts the reality of slain children in the news—a dichotomy between the stark inequity faced by black youth and the universal naivety of childhood."[5] Under a canopy of papier mache balloons, the artist re-created a play space for the children who are disavowed from the protective hold of innocence. In one corner of the room a stack of oversized blocks tower above a pair of sneakers: rearranged, the letters

QUEER TEMPORALITY IN THE PLAYROOM        53

on the blocks would spell Tamir (Felsenthal 2016). On the walls of the gallery space, on top of pink wallpaper with white dots, Patterson hung large-scale, mixed-media portraits of children. Soccer balls, a dollhouse, and video-game controllers are placed throughout the room, also meant to restore childhood to Black children. On one wall, a collage of twenty-one Black children and youth depicts them in a variety of poses. Some meet the spectator's gaze, some look at each other, while others look away. The portraits are embellished by hand; beads, glitter, buttons, and rhinestones on hand-cut matte photo paper are used to render the children's images. In making aesthetic choices that overstate their innocence, Patterson asks her audience to understand why she feels it necessary to reinscribe her subjects with qualities that are nonthreatening. Another wall displays a set of four portraits, three of boys and one of a young girl. On the chest of one of the boys Patterson has glued plastic letters that read "Worthy." In creating the installation, Patterson has said that she was "reacting against the perception of black children in underserved communities as culpable or dangerous, and the systemic racism that has denied boys like Trayvon Martin and Tamir Rice the luxury of youthful innocence" (McKeon 2016). A fourth wall of the exhibit space was decorated with vibrantly colored butterflies that appear midflight, perhaps symbolic of the developmental metamorphosis denied to these children.

Commenting on the exhibit, Lucy McKeon suggests that "by surrounding her subjects with the exaggerated ornamentations of childhood, Patterson hopes to challenge viewers to question their own perceptions of race and age, guilt and innocence" (2016). Even as the figure of the child is emblemized as the future, racialized forms of embodiment produce the

conditions of becoming that children are subjected to. Childhood is a site of exploitation and emergence, but there is also the diminution of some childhoods at the same time that there is the exaltation of others. Indeed, the invidious sociopolitical work performed through childhood innocence allows for a host of damages to be done to children. Innocence is also contingency, negation, and a brutal wounding that considers the needs of some children over others. *In Racial Innocence: Performing Childhood from Slavery to Civil Rights* (2011), Robin Bernstein produces a genealogy of the concept of childhood innocence and its place in racial imaginaries. Childhood innocence, she shows, is a racial formation with a historical character that is keyed into global itineraries of capital. Bernstein's scholarship creates and interprets an archive of evidence collected from a wide range of sources that demonstrates how "the connection between childhood and innocence is not essential but is instead historically located" (4). Childhood innocence is, rather than natural, the effect of a discursive practice that has been shaped by histories of race and gender. Bernstein confronts the often intentionally forgotten racial history of childhood in order to show how innocence is not extended equally. Her important study illustrates that there are racial disparities coded into the paradigms of innocence and sentimentality that have a long history that can be read for their contemporary political symptoms.

Lee Edelman, the queer theorist, casts the Child (capitalized in an effort to distinguish the symbolic economy of childhood from material children), as the object for which all political judgements and beliefs are justified (2004). The Child, he suggests, magnetizes fantasies of continuity and futurity. But, for the material child who is overburdened with the

structural inequalities inherent in a world rife with racism, classism, and homophobia, for example, the symbolic economy of childhood innocence does not offer equal protections against violence. The effect of Ebony G. Patterson's installation expresses some of the material struggles children can endure when not consigned to a position of inculpability. Such struggles are often obfuscated and elided by a pernicious universalism that circulates in child development theory, which rarely allows recognition of the emergent threats to nonwhite childhoods. Universalism is rampant in developmental theories of childhood (all children enter the world without reason, culpability, experience) but there is a severe injustice in the application of innocence based on race, racialization, gender, ability, sex/sexuality, circuits of global capital, and the related biopolitical dimensions of the child's growth. Child development theory often sublates difference in order to prop up the figure of the child as a unitary object that requires the adult's sympathy and knowledge. Others have, importantly, tried to wrest developmental theory from its universalism (Burman 2008, 2010; Castenada 2002; King 1995. These scholars show how the afterlife of slavery and colonialism, their new forms of segregation, and continued differential treatment by services meant to protect children, enable the encryption of racism and sexism in the rhetoric of innocence.

Kathryn Bond Stockton suggests that insistences on universal innocence have the reverse effect of making the child a "queer" figure (2009). Both Hobin and Patterson visually engage the queer temporalities of child development, where some children grow up too quickly and knowledge is withheld from others. Because the artists contest the pace at which children are told they should grow, they render a queer

temporality in which the child forces us to contemplate what sorts of futures should be inherited. Innocence recodes childhood as passivity, a time of depoliticized neutrality, but both Patterson and Hobin queer childhood development in order to demonstrate the child's active engagement with the surrounding world, particularly through the symbolic labor elicited in play. Paradigms of childhood innocence maintain a certain disciplining of time and space; the complexity of children's experiences must be repressed from public life, memory, or recognition in order to sustain its myth. Sequentially elaborated, children are expected to reveal their personalities in time. Hobin and Patterson's art occasions consideration of an indeterminate time that is uniquely created and housed in the playroom. Time, in the playroom, passes queerly because emotional entanglements with past experience are symbolized for their ability to clarify the future, despite social norms of the present. Play, as Winnicott and Klein understand, can alter our affective capacity for reparation and enlarge imaginative capacities: "For the child it is legitimate for the inner world to be outside as well as inside, and we therefore enter into the imaginative world of the child when we play the child's games and take part in other ways in the child's imaginative experiences" (Winnicott 1987, 71). Put otherwise, in play's lack of rules and conventions, the queerness of imagination is propelled. Taking notice of play's queer temporality can help to facilitate a shift in how childhood is observed, theorized, and lived. Both Hobin and Patterson raise inquiry into the untimely time of childhood, in which the child knows too much or not enough and is either withheld from danger or is construed as threat.

## QUEER TEMPORALITY IN THE PLAYROOM    57

In her title, ... *when they grow up* ..., Patterson places ellipses both where a past and where a future should be. What happens to and for her child subjects in the ellipses? What makes a livable future for the spectral figures whom she memorializes? Perhaps the ellipsis operates as a series of psychic displacements that cannot have symbolic life but still nudge at the limits of representability. The ellipses, then, registers a queer space of unknowing, in which the artist and her audience can play with the psychic, social, and epistemological material repressed under the restraints of innocence. The ellipsis placed where a future should be is a significant cleaving of her child subjects from normative measures of time and development. The ellipsis does not stand in for a space where nothing happens, rather it is a scene of activity that is "also a way of signaling an elision. Sometimes the referent is beyond words" (Berlant 2014). In the ways that Patterson's subjects sway outside of both present and future, now and then, and Hobin's child subjects play with the violence of events withheld from them, they signal the queerness of childhood.

If innocence maintains a certain disciplining of time and space, queer is other than the social contract that underwrites the child's relationship to the future. Carla Freccero proposes that we understand "queer spectrality as a phantasmatic relation to historicity that could account for the affective force of the past in the present, of a desire issuing from another time and placing a demand on the present in the form of an ethical imperative" (Dinshaw et al. 2007, 184). Queer spectrality, irreducible to teleological development, captures the temporal divergences of childhood innocence and its mapping of futurity. Halberstam's well-known scholarship on queer time and space is helpful here for its suggestion that queer time is

## 58    THE QUEER AESTHETICS OF CHILDHOOD

"the perverse turn away from the narrative coherence" of the life stages and "the embrace of late childhood in place of early adulthood or immaturity in place of responsibility" (Dinshaw et al. 2007, 182). An invitation into the playroom is a chance to touch the queerness of time; specifically, in Edelman's words, "the queerness of time's refusal to submit to a temporal logic" (Dinshaw et al. 2007, 181). Rather than help to describe a developmental ascent from innocent childhood to reasoned adulthood, or from a childhood never recognized as child-like, queer temporality accumulates beyond the developmental calculus of innocent childhood.

In this schema, adulthood does not simply replace childhood, as adults and children can collectively inhabit queer time. Queer temporality does not register a dramatic rupture between childhood and adulthood because the remnants of childhood experience are a queer presence in adult emotional and social life. Accepting the queerness of temporality makes room for notice of what David Eng calls "affective correspondences," which are "emotional analogies" that join the "present with forgotten moments from the past, carving out a space for what-could-have-been in the now" (2010, 186). In embracing the queer temporality of childhood experience, one might notice an intricate web of psychical negotiations that undermines the ability to separate childhood from the adult's emotional and political life. In the queer temporality occasioned in the playroom, displaced objects and queer connections find symbolization. Queer temporality provides a physical and conceptual space in which to recognize the limitations of splitting childhood experience from adulthood. Queer time, called into being through the act of play, holds open a space for that which is abjected from the regime of

innocence and creates a potential space for expression of history, memory, and agency otherwise disregarded. When adults enter the space of play they have the opportunity to dislodge remnants of what has been repressed and to mine traces of queer desire. The purpose of play, if we think alongside Farley, Klein, and Winnicott, might be to "transform old material into new combinations of memory" (Farley, 2014, 17). Entering the child's playspace can increase empathy because it offers a reminder of early pleasures and frustrations that stubbornly attach themselves to adult ideals, desires, and libidinal structures of relationality.

I have not meant to conflate the aesthetic or political strategies of Hobin and Patterson, but to hold open the tension, dissonance, and polyphonic appeals between their work as a way to rethink childhood innocence. Both artists stage an aesthetic protest against the taming of children's desires and curiosity, but they do so on account of different theses. An invitation to both of their playrooms means the potential to commune with specters of the past and the evacuated but not eviscerates histories that cling to present discourses of child development. In their playrooms, we might feel the effects of ungrievable losses; notice tendencies for splitting love from hate, good from bad; but also, restore hope. What ties their work together is that both artists motivate an encounter with the child's playspace and help their spectator to move across and beyond the temporal borders of childhood and adulthood. Before concluding, I offer a reading of one of Hobin's photos for its queer depiction of childhood. Unlike Patterson's child subjects, who are positioned within a queer temporality that results from an insecure border between life and death, childhood and adulthood, Hobin's subjects are

60 THE QUEER AESTHETICS OF CHILDHOOD

queered in the conflict staged between stereotypes of innocence and their active engagement in social violence. Hobin foregrounds the child's playspace as an arena for the enactment of "difficult knowledge" (Pitt and Britzman 2003) and its queer revisions to developmental theory. In her reflection on "In the Playroom," Sara Matthews emphasizes the photographs' pedagogical value. She writes, "I get the impression that Hobin is attempting to shock the viewer into thought. But affect is a wild thing, not so easily tamed by the photographic frame" (2013).

Matthews offers an incisive reflection on *A Boo Grave*, a photograph in which Hobin reconstructs the widely circulated image of an act of torture at Abu Ghraib, Iraq, caused by American military personnel. She questions the ethical purpose and pedagogical intent of the photograph, in which Hobin uses child actors to re-stage the now infamous photograph in which a prisoner stands, hooded, on a box with arms outstretched. Matthews writes, "Hobin's image performs more than just a commentary on the relations between the media and society—it actually offers up the original scene for consumption one more time. My worry is not about the preciousness of the original photographs but rather whether Hobin's reinterpretation opens the possibility of a different relation to the social and political realities represented here?" In its pedagogical interference into the social construction of childhood, Hobin's photographs also beg inquiry into the ethical witnessing of torture, war, death, and other social crises. Matthews continues to ask, "does the image put shock into the service of thinking and if so, is that a good enough reason to re-circulate scenes of dehumanization that the photograph both represents and reconstructs?" (2013). Further, if the series

## QUEER TEMPORALITY IN THE PLAYROOM 61

is meant to humanize "the child" so that an adult viewer recognizes its active participation in a violent world, what does it mean to do so through the act of repeating an image so contested for its racialized impact? To what extent is Hobin, paradoxically, implicated in the naturalization of childhood innocence? In staging children and placing them within scripted and deliberate poses, they are not exactly creatively involved in play but are parodic versions of original, adult actors. In *A Boo Grave*, the children cannot wholly demand their own epistemological and ontological saliency outside the adult artist's reconstruction of a controversial image.

How can the children demand their own ontological consistency, affective yearnings, or political sovereignty when staged as the adult's double? The enigmatic qualities of play and its spontaneous creative labor is not entirely at work here, and thus the children's ability to work with the confusing properties of the repressed and its uncanny return is diminished. Whereas Patterson builds a playroom where innocence is reclaimed and restored in order to show how the Child, expected to engender optimism and futurity, is not all children, Hobin inserts children into a traumatic political event to "shock" an audience into noticing their lack of innocence. Rather than open up a queer temporality in the way that Patterson's playspace does, *A Boo Grave* repeats a contested event in an effort to highlight the uncontainable impact of geopolitical conflicts on children's development. Patterson created a playroom for children who cannot escape the histories of racism left on their subjectivity, whereas Hobin's child actors are staged in ways that constrain their queer creativity.

## The Delicate Act of Interpreting Play

Ebony G. Patterson's and Jonathon Hobin's aesthetic engagements with the playspace each propose a way of bearing witness to, and being with, the child's symbolic expression of difficult knowledge. Both artists foreground children's play in an effort to consider how the overpowering rhetoric of innocence and feelings of nostalgia and sentimentality surrounding childhood is most often also imbued with negativity, ambivalence, and even violence. In reading their work for its affective and psychosocial dimensions, I have proposed that play's ability to disrupt the flow of time offers a chance to repair histories of abjection. The delicate act of interpreting art about children involves recognition that the constitutive trope of childhood innocence can impress upon the most radical theories of human development, even while working against its influence. For the adult, encountering Patterson and Hobin's playrooms provides a space for the continuation of play and acts as a potential space in which to repair the violence that underwrites dominant epistemological treatments of childhood development. Their art enhances theories and critiques of childhood so that an empathic identification with children can be created. I have asked if and how Hobin's and Patterson's playrooms strengthen our ethical obligations to children. In doing so their visual vocabularies of childhood have sharpened a range of questions about how the adult's fantasies of globality and politics, race and innocence, and the affective imaginaries of development come to bear on the futures children create and contest.

Children are often "raised" with a resolute idea of what the future should bring, but in play, and its interruption to

time, they may fantasize otherwise. When adults step into the playroom they may better understand the need for speculative futures and repair melancholic attachments to the events of childhood. Our interpretations of the purpose of play have to do with both the established discursive limits of childhood and the unthinkable qualities of our own experiences of childhood. Both artists help us to recognize the extent to which the discourse of childhood innocence presses upon the treatment of children. Ann Anlin Cheng advises that, "in the context of unimaginable, persistent racial grief, we must begin to acknowledge the complex nexus of psychical negotiations being engaged and develop a political vocabulary" (2001, 21). I have suggested that Ebony G. Patterson's exhibit, . . . *when they grow up . . .* , creates an aesthetic vocabulary that does political work. In order to grow up the child must, in part, renounce curiosity and creativity, and learn to control affect. To enter the playspace is to enter a potential space of reparation in which children and adults can work through difficult experiences that are sealed off but not escaped from memory.

# 2

## Art and the Refusal of Empathy in *A Child's View from Gaza*

Images of suffering children are regularly used to draw attention toward the devastating effects of war and the territorial partition of land. Relatedly, humanitarian efforts to lure funding and political capital often use pictures and videos of children who are injured, visibly impoverished, or traumatized. As someone who works in philanthropy recently admitted to me, "slap a picture of a child on anything and you're more likely to receive money." The figure of the child who is perceived to be in pain is instrumentalized for its ability to draw concern; the child's vulnerabilities are deployed in the service of ideology and capital. Such images can obfuscate children's political agency and thereby tighten discourses of passivity around them. The philanthropic and humanitarian circulation of images of suffering children is propelled by spatialized orderings of humanity that bespeak a maldistribution of empathy based on race, ethnicity, and citizenship. Below the surface of images of children who suffer from war,

## ART AND THE REFUSAL OF EMPATHY 65

poverty, and political violence is a fraught network of geopolitics and its affective dimensions.

In line with this routinized pattern of behavior, whereby children become the visual emblem of war, images of injured and traumatized children circulate from Gaza each time Israel invades. Indeed, for children in Gaza, war has been a protracted and immanent reality. In Gaza, children have an intimate knowledge of politics.[1] War is frequent in Gaza, a Palestinian territory under Israeli blockade and the regular recipient of bombing campaigns and ground assaults. Images of Gazan children bearing the effects of political violence that comes with settler-colonialism are regularly used as bids to increase international humanitarian aid. This is because Palestinian children's affects are expected to be transmitted to an international audience through confrontation with a visual representation of their pain. At the same time, because speaking about Israel and Palestine is filled with politics, history, and for many, ideology, images that represent the effects of war on Gazan children are often censored in Canada and the United States. In asking what it means ethically and politically to witness these images, I offer the question in reverse: What can it mean to refuse them? These dilemmas matter to a transnational study of the politics of childhood because they engender inquiry into the limits of international human rights legislation and move us into the realm of affect and emotion that can override law.

The United Nations Convention on the Rights of the Child (CRC) is commonly referenced in debates about how to protect children from the damages of war. The convention is highly prized in scholarship and activism concerned with children's rights. A human rights treaty adopted by the United

Nations General Assembly in 1989, the CRC is regularly heralded as the most useful apparatus for protecting children in sites of political violence. The most ratified international treaty in history, the CRC aims to ensure that children are the "subject of their own rights" and that they may "grow-up in an environment of happiness" and have the right to "protection and freedom from war." Lauded as necessary to the well-being and health of children, the transnational installation of child rights doctrines is complicated. The UN's CRC is difficult to operationalize, in part, because it contains narratives of freedom that don't affirm the subjective realities of all children. While the CRC seeks to extend humanity (in the form of childhood innocence) to all children, not all are helped by the liberal cast of "the human." As Lisa Lowe explains in *The Intimacies of Four Continents* (2015), "The social inequalities of our time are a legacy" of the "processes through which 'the human' is 'freed' by liberal forms, while other subjects, practices, and geographies are placed at a distance from 'the human'" (3). The characterization of Gazan children as possessive individuals in need of liberal humanist sympathy can have the adverse effect of eliding their entrenchment and active resistance to the collective devastation of routinized war (Marshall 2013; Rabia, Giacaman, and Saleh 2014). Further, the effects of land seizures, military occupation, and other related logics of destruction, can slide themselves deeper into the child's subject formation than sociolegal and judiciary templates of rights-based protections allow.

This chapter of my study sidesteps the tentatively liberating concept of children's rights and asks instead how the difficult knowledge expressed in Gazan children's art and aesthetic expression can increase empathy. By centering on

## ART AND THE REFUSAL OF EMPATHY 67

these images, the chapter contributes to a conceptual framework and coalitional politic surrounding the realities of Gazan children. I consider how their drawings can archive the social and affective life of war in Gaza. I do so not because their art depicts a "better reality" of geopolitics, for it too is fraught with the impossibility of authenticity, but because it offers a chance to witness the affective refractions of settler-colonialism present in the children's lives. Children's aesthetic expression does not necessarily obey epistemological confines of the social world but can creatively represent the transfer of historical memory into the child's analysis of self. The drawings that I discuss are published in *A Child's View from Gaza: Palestinian Children's Art and the Fight against Censorship* (Middle East Children's Alliance 2012). The children's art provided in the book is a container for the affects of colonial violence. To witness their drawings is to learn about war's impact on child development. The children's art operates as a "regional aesthetic archive" (Gopinath 2018) that counters Eurocentric definitions of childhood. The children's drawings confront us with what Sianne Ngai terms "aesthetic emotions" (2005), the grounds on which feelings and politics can be conjoined. For Ngai, "the very effort of thinking the aesthetic and the political together" is an urgent task (3).

In *The Right to Maim: Debility, Capacity, Disability* (2017), Jasbir Puar, the prominent queer theorist, critiques the NGO-ization of Gaza. She explains that in Gaza, childhood trauma has offered a laboratory for social science researchers, which can deepen a process of value extraction from communities already made vulnerable (152). From a distance, I enter the terrain of debate about children's development in Gaza by asking why children's drawings would be censored from an

American children's museum and what affective possibilities were foreclosed in doing so. Offering an aesthetic and affective mode of inquiry into the violent effects of settler-colonialism on children's development, I consider how and why children's art can operate as emotional and collective resources for dealing with and making meaning from suffering. Linda Tabar (2016) makes the argument that "because the humanitarian paradigm restricts 'compassion' to passive victims, who 'only suffer' but do not 'act,' it disrupts and undermines Palestinians' anti-colonial agency" (16). "Humanitarian compassion for others," she argues, is rooted in ambivalence, and often, Eurocentrism. Her proposition is worth heeding in a study of images of Gazan childhoods that circulate to an international audience with the purpose of producing compassion. Puar offers a method for thinking about the "economy of injury" in Gaza and deficits of empathy. She critically inventories some of the quantitative social facts that resulted from 2014's "Operation Protective Edge, which" killed over five hundred Gazan children and left 80 percent of families "completely dependent on aid" (128). Puar does not offer "a catalog of suffering" (128) based on an assumption that numbers will make evidentiary demands, but does so to explain how occupation makes Gazans "a population available for injury" (128). The emotional intractability of Gazan children's experience is now studied by a multitude of social science researchers and humanitarian organizations. Puar notes that the debilitating effects of occupation and settler colonialism in Gaza have provided raw records available to researchers interested in studying childhood trauma (152). Indeed, Barber et al. (2015) concede that "mental health has been studied more than any other outcome in research on youth in Palestine" (80).

Puar's analysis insists upon notice of how Gazan children's trauma is harvested as data for researchers (primarily from the Global North) to use toward their own agendas. This chapter sits in the uncomfortable axis of being involved in recuperative efforts to know the extent to which trauma is treatable, and the drive to enact transnational solidarity that respects alterity. In the artwork archived in *A Child's View from Gaza: Palestinian Children's Art and the Fight Against Censorship* I find transactive economies between the two poles of this axis: an aesthetic rendering of expendable life in Gaza that is outlined through the experience of violence *and* the potential for children's art to create transnational conviviality, solidarity, and understanding. I aim for my analysis to fall more heavily on the latter, seeking to understand how an American museum dedicated to children's art could turn away from art made by Palestinian children. Rather than being involved in a qualitative or quantitative study of trauma in Gaza, I offer a philosophical commentary on the limits of empathy offered along the lines of race, borders, and citizenship. Nadera Shalhoub-Kevorkian has studied the "underlying structures of dispossession that produce everyday obstacles to the livelihoods of Palestinian children" (2016, 7). She writes, "All colonised people are children once, yet, as I argue, colonised children are denied childhood and their childhoods are distorted by settler state's interventions" (10). Shalhoub-Kervorkian makes the important point that "Children's observations about the dehumanising and violent behavior surrounding home demolitions hint at their understanding of the racial politics that guide these confrontations" (13).

My reading of *A Child's View from Gaza* (as text, as cultural event, and as historical archive) initiates dialogue about the

# THE QUEER AESTHETICS OF CHILDHOOD

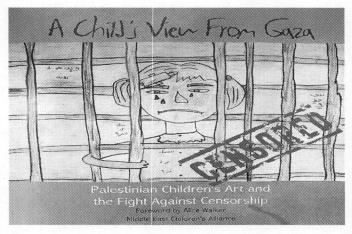

**FIGURE 2** Cover of *A Child's View from Gaza: Palestinian Art and the Fight against Censorship.* Courtesy of Middle East Children's Alliance.

relationship between aesthetic expression, compassion, and settler-colonial politics. The drawings that are published in the book were originally censored by a children's museum in Oakland, California, where they were to be exhibited. A campaign was waged against their potential display because they were deemed too graphic for children. Such censorship begs deeper inquiry into the social construction of childhood in a transnational frame: How could it be argued that art made by Gazan children did not serve children? Thinking about this paradox means that we must again consider the racialized asymmetry that children have to an innocent futurity that can defend against death. By naming them essential to a transnational archive of childhood, I endeavor to trace a different narrative out of the drawings than one that renders them disposable and dangerous.[2] The children's drawings are an affective repository and alternative visual archive that some

want lost. In censoring the art, there was a refusal of empathy and, as I will suggest, a refusal of the transmission of affect (Brennan 2004). The emotional tonalities of the Gazan children's artwork problematizes the immobile geographies of children's innocence by rendering present the effects of political conflict and war on children's subjectivities. They are a reminder that we can't universalize the child's attributes precisely because they are individualized by such forces. My study of the drawings points to the threshold of the category of children's rights by refocusing art's capacity to create empathy and rupture colonial forms of knowing and ordering life. I use the book's visual vocabulary to open up a range of questions concerning adults' ideological investments in fantasies of universalism, race and innocence, and childhood. *A Child's View from Gaza* enhances thought on discourses of childhood innocence as it poses ethical conflicts for the adult.

In her study of children and America's large rates of incarceration, Erica Meiners (2016) importantly asks: "Who might be eligible for the benefits associated with childhood?" (3). The question points toward an asymmetry of care that privileges the realities of some children over others. Applying Meiners's inquiry to the censorship of Gazan children's artwork on the grounds that it is too graphic for children to witness, it becomes evident that childhood innocence is unevenly distributed. Tina Campt's method of describing the sensorial potentials of art is useful in contemplating what was refused in the children's drawings. Campt's stunning monograph, *Listening to Images* (2017), stages "haptic encounters" with photographs; in doing so, she "foregrounds the frequencies of images and how they move, touch, and connect us to the event of the photo" (9). Campt's theorizing inspires the question: What

affective and sensorial registers were left untouched when the Gazan children's artwork was censored from the children's museum? When viewed, the children's drawings offer the gift of collaborative exchange between artist and spectator; becoming witness to them asks an audience to remain open to the child's pain and to feel the weight of what might otherwise be untenable identifications. The aim here is not to annihilate or strengthen the difference between children's and adult's experiences of settler colonialism, but to spark inquiry into the children's vulnerability and mutual political agency.

Dina Georgis (2013) asks what it can mean for affect and for politics if we "listen queerly" to another's suffering. Like Campt, Georgis theorizes a way to listen ethically to the stories contained in art. For her, the act of listening queerly is an interpretive and ethical practice that requires resisting narcissistic identification in order to empathize with another. Listening queerly to the narrative shared in *A Child's View from Gaza* involves what Georgis outlines as an ethical paradox: "it attends to being affected but is neither disengaged nor wanting to master what it sees and hears" (18). Drawing on Georgis, I invoke queerness here not as identity but as rubric and method with which to gather and name the affects that are transmitted in and through the children's drawings. While some may find it odd to use queer critique to study children's drawings, my consideration of *A Child's View from Gaza* and the debates that surround it is strengthened by an attempt to "listen queerly" to its narrative. C. Heike Schotten proposes a "decolonial alliance" between queer theory and Palestine studies, for their "shared aspiration toward constant unsettlement" (2018, 16). Schotten writes: "Indeed, the inassimilable is in some sense who and what queer names—that illimitable

list of deviant others whose existence destabilizes, disrupts or thwarts the otherwise smooth functioning of institutionalized, hegemonic regimes of normalizing, heteronormative power" (16). The narratives contained in the Gazan children's drawings could not be assimilated into the museum's narrative of childhood, thus they became unintelligible to its mandate. In the next section, I describe the origins of *A Child's View from Gaza* in order to consider why children use art to resist the perpetual stripping of filial attachment, land, and other horrors resultant from the long *durée* of occupation. I then theorize art's potential for affective integration after traumatic experience. By interlacing a critical reading of *A Child's View from Gaza* with broader questions about the affective underpinnings of children's art and their aesthetic expressions of unquantifiable grief, I consider how the children's grievances against war reappear in their cultural productions.

## "This Is the Peace They Support"

In 2009 a delegation of concerned Americans traveled to Gaza to witness the aftermath of Israel's invasion, "Operation Cast Lead," which killed 352 children. While there, a member of the delegation visited an art therapy class where drawing was being used to help children communicate their feelings. The drawings that were made offered evidence of the psychosocial impact of partitioned, occupied, and militarized space on Gazan children's imaginations. As supplement to the social facts of death and expendable life, the artwork archived the traumatic effect of settler-colonialism on their fantasies. The American delegates then had the idea to share the children's drawings with a broader audience in the form of a traveling

74    THE QUEER AESTHETICS OF CHILDHOOD

exhibit, which would move between museums and community centers in the United States. Intended to educate an American audience on the impacts of war, it was believed that the drawings would reveal the children's political conditions and create empathy while increasing resistance to the occupation of Gaza. The Museum of Children's Arts (MOCHA), in Oakland, California, was chosen as one of the sites where the drawings would be exhibited. After heated debate, pressure from community members who believed the art too "graphically violent and sensitive" (61) ultimately resulted in the cancellation of the exhibit. After six months of preparation and sustained discussions about "educational programs and events to complement the exhibit" (16), MOCHA's board of directors revoked permission for the artwork to be shown. A storm of debate erupted in the Bay Area, with heated conversations about what is at risk when children's artwork is censored. My tracing of the exhibit's genealogy and its grim response relies on the book's narration of events.

Arguably, what was to be lost in the cancellation of MOCHA's exhibit was an opportunity to learn from Gazan children. Knowledge about settler-logics of war and their relationship to children's development was on offer in the opportunity to exhibit the artwork. In canceling the exhibit and with it a new audience's opportunity to become educated in the passions and protests of Gazan children, there was a refusal to learn. Drawing from the space of loss, the children's art is about grief, but it is also about the collective survival of a generation of children who are not inflated with precious innocence. Their art narrates and creates lessons from complex engagements with death, colonialism, war, and terror. Thus, to witness their art with an openness to being changed

forges methods for rethinking childhood in a global frame. The lessons provided in the exhibit were not resolute on how to fix children's grievous loss, but there was the opportunity to forge empathy by prying open the edges of "childhood" so that the affective resonances of war were felt. The education that could have been gleaned from the drawings was rich and vital. Placing their artwork on display in a museum that is involved in the project of determining what counts as appropriate for children could have helped to reconstitute transnational imaginaries of development and care.

Then, in an act of collective and creative resilience, an empty storefront was rented and transformed into an alternative gallery where visitors could see the art. The remade exhibit held open the representational force of the children's drawings. Later, in 2012, Pacific View Press published *A Child's View from Gaza*, which then further circulated the drawings and told the story of their complicated response with a larger audience. With a foreword by Alice Walker titled "Empathy Is a Wave," the book contains forty-four children's drawings, short essays written by members of the American delegation who bore witness to the effects of occupation in Gaza, and news articles about the first exhibit's censorship. The book details how cultural anxieties about race, Zionism, and debates about the ethical imperative to care for all children were inflamed by the children's art. Because the children's art raised trenchant questions about the biopolitics[3] of children's creative labor and the therapeutic capacities of art in a place where the evacuation of life is habitual, its exhibition within the children's museum would have offered alterations to its theories of childhood. In hanging the art in the children's museum, an audience could have noticed the constitutive

omissions of certain forms of experience in its conceptualization of what is appropriate for children. However, in the form of a makeshift alternative and later, a book, the circulation of the drawings allows an international audience to confront material traces of what is otherwise potentially inaccessible: the aesthetic rendering of what it feels like to be stripped of kinship, to be scared of missiles, to lose a home or a school. The drawings aesthetically communicate how it feels to be what Puar characterizes as being "embedded in a distribution of risk already factored into the calculus of debilitation" (xiv).

A drawing by Rafeeq Omar Isalami, noted as being in fourth grade, is one of the artworks showcased in *A Child's View from Gaza*. In his drawing, a man is on his knees with his hands raised in the air while a soldier holds a gun pointed at him. The background behind the soldier is colored bright yellow while the kneeling man is drawn against red. A drawing by another child, Mohammed Tayseer Summad, shows a tank and a missile crashing into a building. A body is caught underneath the tank and on the missile "this is the peace they support" is written in Arabic. On another page, a drawing by Reema Al Shaaer, noted to be ten years old, shows missiles being dropped onto buildings and people. The scene exists under a yellow sun that is humanized with tears drawn on its face. In the drawing, six stick figures lie in a pool of red and a vehicle appears with a red light on top. Most of the drawings contain blood, bombs, missiles, and human figures lying on the ground, appearing to be injured. The children's impulse to aesthetically symbolize experiences with death and suffering substantiates the pedagogical potential for their artwork to incite dialogue. It is likely that they can't relinquish

## ART AND THE REFUSAL OF EMPATHY 77

knowledge of violence because it has been introjected on both psychical and social planes. In the commonality of their losses, as archived in the book, an audience glimpses the internal experience of suffering and thus experiences the productive power of its unleashing into the social world. It is impossible to know what traces of loss appear in the children's art as fantasy or fact; rather, the drawings dramatize the profound ways in which settler-colonialism impresses upon their subjective reality.

On one of the last pages of *A Child's View from Gaza* there is a quotation from a Reuters news article that states, "Palestinian health experts studying the impact of Israel's blockade of the Gaza Strip say it threatens to cause long-term damage to Palestinians' health" (72). The book offers children's drawings as evidence and archive of the affective turmoil caused by the blockade and invasions. The children's drawings may be understood as accusations against an adult world that failed to protect those they loved most, as they archive mnemonic and felt evidence of the trauma that lives within them. But the drawings are not only a product of wounded subjectivity, they also reveal a complex understanding of politics, and thus, fortitude. Creating a venue for children's aesthetic practices may be an ethical mode of being with a child's trauma, but also our own complicity in its existence. Saidiya Hartman, working toward an ethics of witnessing the pain depicted in images of transatlantic slavery, writes, "What interests me are the ways we are called to participate in such scenes" (1997, 3). She asks, "What does the exposing of the violated body yield?" (3). At issue, for her, is the "precariousness of empathy and the uncertain lines between witness and spectator" (3). I apply this inquiry to the drawings offered by

78    THE QUEER AESTHETICS OF CHILDHOOD

Gazan children, in order to call into question the ethical dilemma of arriving too late to the child's suffering. Images of war in Gaza and images of the pain of transatlantic slavery have their own political, embodied, and historical narratives. They leave unique historical impressions on contemporary childhoods. Required, then, is an ethics of bearing witness to Gazan children's symbolic expressions of war and its affective consequences that notices the "precariousness of empathy" (3).

Confronting the children's artwork can push an international audience to expand conceptualizations of child development by accounting for Gaza. The art's censorship was arguably intended to block feeling and a potential transmission of affect. Those who lobbied for the exhibit's closure were perhaps worried about the authenticating force and empathic potential of drawings by the children of the occupation. On some level, they were aware that spectators may not remain indifferent to its effects or what Teresa Brennan may have described as its "transmission of energy and affects" (24). The art, if carefully viewed, could transmit more complex affective states or agitate current affective states and create a coalition with the "affective refuse of a social order" (Brennan 2004, 67). It is difficult to sever affective ties between art and audience once they are emotionally impacted. In thinking of the cancellation of the exhibit as a refusal to learn, we might describe the artwork as a resisted resource for enhancing understanding of the relationship between settler-colonialism and child development. Deborah Britzman, the educational theorist, writes, "Learning is a problem, but it has to do with something other than the material of pedagogy. We might begin to pry apart the conditions of learning from that which conditions

## ART AND THE REFUSAL OF EMPATHY 79

the desire to learn and the desire to ignore" (1998, 5). Thinking with Britzman, the desire to ignore Gazan children's art was, in part, an aspiration to certify forms of geopolitics and a hope that affective lives would not be unsettled. The worry may have been that the art would cause its viewers to defamiliarize themselves with what they knew and in turn, inspire alliances not previously probable. It is this code of affective restraint, precisely, that desires knowledge of Gazan children's suffering to be refused. The potential to turn the gallery into a space where grief is socialized and treated as valuable to the design of education was lost in the cancellation of the exhibit.

## Violence and Affective Labor

The children's drawings in *A Child's View from Gaza* posit a notion of time that is nonlinear. In the present, they depict memories of the past that remain central to the child's understanding of the future. The affective labor contained in the drawings stages an active encounter with the residues of loss impressed upon the children's imaginings of their social world. Traumatic experience leaves a trace that can later become energetically determinant in a subject's relational life. Cathy Caruth (1996), Dina Georgis (2013), and Gayatri Gobinath (2018) all suggest that memories of historical trauma are embedded in visual culture and that the emotional excess of political crises leaves its mark in aesthetic expression. Relatedly, in children's drawings, their aesthetic choices often contain evidence of what is not forgotten but is in excess of words. The political imaginaries expressed in the Gazan children's drawings convey the affective impact of military occupation, resource extraction, economic instability, and

80  THE QUEER AESTHETICS OF CHILDHOOD

fear of death. In children's art, like in their dreams and in their play, affect not enjoined to materiality or intrinsically related to reality may surface. In treating children's drawings as dreamscapes where unprocessed memories that disorganize the ego may find expression, my analysis of the drawings in *A Child's View from Gaza* asks not what truth they capture but what they accomplish for affect, for politics, and for the future. In their art, children may not only mimetically represent experience, they can also offer insight into how grief and suffering inform their sense of self and their dreams (both unconsciously and in daydreams). That is, creating art allows children to touch and represent the nonlinearity of time. In the act of drawing, the affective accumulation of war and remainders of traumatic experience can surface, helping the concerned adult to observe where the relationship between creativity and subjectivity has been damaged. The violent incursion of war and its previously un-narrated violences can turn children's aesthetic expressions into a repository of grief and trauma that expresses some of the psychological negotiations they are making with the social world.

Samir Qouta, Raija-Leena Punamaki, and Eyad El Sarraj's work on the psychic and symbolic functioning of Gazan children's dreams "confirms the intensification of play after acute traumatization" (2008, 315). Their study also suggests that "highly traumatized children remember more of their dreams than less traumatized ones" (315). "Both phenomena," they believe "can be interpreted as the urgent need of humans to work through, rehearse and repeat painful and bewildering experiences until their emotional load is neutralized" (315–316). In asking whether children's symbolic processes function as "a kind of self-healing practice" Qouta, Punamaki,

and El Sarraj conclude that Gazan children are enabled to "emotionally re-experience painful, devastating and shameful events in the safety of a dream, cognitively to frame their overwhelming emotions and arousals, and to seek a wider range of associations (316). While the act of drawing may pull differently on the relationship between the unconscious and waking life, if it is treated as an ally to the dream's psychic function, the children's artwork may help to untangle their relationship to loss. This may not allow them to be measurably "cured" but rather, may permit violences' long shadow of impact on subject formation to be better understood. A reprieve from the confines and spatiotemporal regimes of a difficult past, a piece of art offers a potential venue for a subject's reparative tendency to be ignited.

It seems pertinent to ask what a theorizing of suffering and related clefts between mourning and melancholia can do for Gazan children caught in the aftermath of the violence of Operation Cast Lead (and subsequent invasions). In engaging with the drawings in *A Child's View of Gaza*, this chapter submits that the pervasive eurocentrism of psychoanalytic theories of trauma hinder (but do not break) its potential to discuss the impact of land seizure and colonialism. The potential salience of psychological and psychoanalytic theories of trauma and memory lies not in their perfection but in the questions they raise around the relationship between imaginings of the future and the repetition of memories of the past. There is a large body of literature that thinks through the politics of mourning as a counterpoint to the tendency to individualize trauma (Ahmed 2004; Cheng 2001; Eng and Kazanjian 2003; Fanon 1963, 1967). This literature studies affiliations between the social construction of identity and

82    THE QUEER AESTHETICS OF CHILDHOOD

the psychological terrain of subjectivity. Central to this line of inquiry is the belief that how a subject perceives the outside world is determined by internal psychic impressions (and vice versa).[4] This means, then, that the individual subject's grief is both their own problem and refracted through their interactions with others. In keeping with the spirit of this literature, I employ the language of trauma not so that collective memories of violence are obscured but rather, so that the social reverberations of an individual's loss are considered. In the 1960s, Frantz Fanon wrote eloquently about the objectification and dehumanization that was carried into and equally produced within the clinical treatment of trauma. Medicine and psychiatry, he asserted, were rampant with white supremacy and required a decolonial politic. Fanon's writing expresses a process of becoming conscious of how mental health is inscribed with colonial science.

In theorizing trauma as both an individual and a social occurrence, the desire is not to propose that it is easy to get over or repair because it is common in its sharing with others, but instead to mine its ambiguous margins for traces of both private and collective grief. Toward these ends, I draw on literature that moves beyond individualized accounts of violence in order to place suffering within a wider network of culture, social life, and history. Broadly, the field of trauma studies (Herman 1992, LaCapra 2014, Leys 2000) advocates that the representation of difficult experience should be studied not only for what it remembers but what cannot be forgotten. One example of this scholarship is Anne Anlin Cheng's insistence that "psychical experience cannot be reduced to a mere replication or a fully compliant repository for social injunction" (2001, x). The psychical process of grief, she posits, is

## ART AND THE REFUSAL OF EMPATHY  83

"not separate from the realms of society or law but it is the very place where the law and society are processed" (x).

Cheng describes the ways that aesthetic texts can capture traumatic memory not otherwise accessible to law or social institutions. She advances a line of argument that clarifies how racial abjection is at work in America's melancholic attitude toward its history of transatlantic slavery and social exclusion of Asian Americans based on race. For her, America's project of nation-making has involved an inability to mourn racial violence, but aesthetic objects such as literature and art help to lift the weight of melancholia. Pivotal in Cheng's theorizing is Sigmund Freud's model of melancholic attachment, wherein the subject "sustains itself through the ghostly emptiness of a lost other" (10).[5] In her study of the "fraught network of ongoing psychical negotiation" that propels racism, Cheng does not prescribe how a nation might go about "getting over" history. Rather, she asks "what it means for social, political and subjective beings *to grieve*" (7). The artwork in *A Child's View from Gaza* does just this: it asks for notice of the inscription of grief left on the children's aesthetic expressions. To listen to the imprints of difficult histories on psychic life, explains Cathy Caruth, means holding open space for "an address that remains enigmatic yet demands a listening and a response" (1996, 9). To listen queerly to the children's drawings means recognizing that the checkpoints, deaths, and other mechanics of occupation that appear in the children's art are essential to their understanding of self.

## Despite Censorship

Children's art is often relegated to the margins of knowledge production, but here it has been treated with respect for its ability to assist in processes of mourning and to create affective and political coalitions between people, objects, and histories. In asking what pedagogical possibilities were foreclosed when the Gazan children's art was framed as inappropriate for children to view, this chapter has sought the alignment of child studies and settler-colonial studies. Exposure to war not only causes grief but can also lead to politicized resistance, which causes epistemological confusion for those who prefer to empty childhood of complexity. I have theorized the children's drawings in *A Child's View from Gaza* as a site of social reproduction that both resuscitates the fracturing abuse of occupation and enunciates the potential for alternative futures. In viewing the images we have arrived too late to the scene of violence that caused the child suffering. The drawings archived in *A Child's View from Gaza* are the creative outcome of the need to continue amidst suffering and communicate its political consequences for the future. The nature of this archive is, of course, complicated. While there is a political utility and ethical necessity to its viewing, I am not interested in the shocking and the spectacle, but embrace the pedagogical and affective capacity of these images to reshape definitions of childhood and to build transnational coalitions.

In the drawings, the children's representational techniques and aesthetic choices are not only a subsequent act of retelling the events of war but an attempt to symbolize the latent force of injury to an audience that could help to bring justice. As much about their feelings is revealed as concealed

## ART AND THE REFUSAL OF EMPATHY          85

in the drawings, yet their anterior contours build a suggestion that the children are revisiting scenes of suffering as much as recalibrating the effects of living in the shadow of war. My consideration of *A Child's View from Gaza* has not drawn Gazan children into a singular relationship to the environment, but contemplated a varied response to the collective experience of living under siege. Although it would be a mistake to collapse the range and diversity of responses to invasion, the drawings do hold patterns in their orderings of space and objects. Against the collective tragedy of death, their aesthetic expressions generate complex connections and compel identifications previously absent. As children are in the process of constructing social and symbolic systems that will determine their responses to future conflict, offering a creative space for them to mourn and communicate the traumatic loss of home or safety is essential to their development. Especially salient to the arguments forwarded in *The Queer Aesthetics of Childhood* is *A Child's View from Gaza*'s testament to children's agency and immersion in politics. The drawings aesthetically communicate wounded attachments to people and things now lost but also, demonstrate the need for more documentation of settler-colonialism from children's perspectives to enter public spaces such as art galleries and museums.

# 3

# The Queer Remains of Childhood Trauma

## Notes on *A Little Life*

Jude, the protagonist in Hanya Yanagihara's novel, *A Little Life*, experiences a traumatic childhood. His boyhood is a story of captivity and horror, and the symptomatic afterlife of traumatic experience. Jude's history of childhood abuse is so absorbing that as an adult it continues to denigrate him and is encrypted in his imaginings of the future. Left in a dumpster as an infant and then raised in a monastery and a succession of temporary homes for orphans, Jude's childhood does not rest safely in the past and retains affective intensity in his adulthood. A novel about the lasting effects of childhood trauma, *A Little Life*'s crucial lesson is that childhood memories often correspond to adult experience.[1] Jude's traumatic boyhood is foregrounded as essential to his adult fantasies, subjectivity, and affective disposition. And so, through Yanagihara's narrative, one enters the psychosocial and analytic space of trauma. Her readers are then asked to consider what conditions are needed for therapeutic mourning of

## THE QUEER REMAINS OF CHILDHOOD TRAUMA 87

childhood abuse. Without prescribing an answer, the novel reminds its reader that the confusions and injuries (both psychic and material) of our childhoods reappear in queer ways in adulthood.

Thickening the theory of childhood mourning that was begun in the last chapter, this chapter engages with *A Little Life* as a way into a conversation about the lasting impact of childhood experience. The novel, a form of art, aids in a discussion of the psychic vulnerabilities and narrative implications of trauma and the queer remains of childhood that are left on adulthood. The chronic sexual and physical abuse that Jude experiences is a wound to his childhood development, the latent force of which causes difficulty in feeling loved as an adult. I consider the novel for its aesthetic elaboration of the afterlife of a violent childhood and depiction of how trauma agitates linear development, causing what Kathryn Bond Stockton calls "sideways growth" (2009). Eventually, the emotional force of the abuse causes belated fatality in the form of a suicide. The novel thus asks its reader to consider what it means to survive well after traumatic experience and in raising the question, elucidates some of the complexity of thinking with and caring for traumatized children. I read the text as an elegiac meditation on the psychic terrain of unbearable childhood experience that is not extinguished with the passing of time. If childhood cannot end with a sense of finitude but rather, mutates and persists, then a new theory of development is required. Engaging psychoanalytic theories of trauma and its symbolic dimensions, I follow the line of thinking begun in chapter 2 to consider the novel not only for its exploratory scenes of child abuse but also for the ways the text conveys the ethical problem of witnessing another's suffering. As

88     THE QUEER AESTHETICS OF CHILDHOOD

an adult, despite being surrounded by friends and family who love him, Jude's pain cannot be adequately cared for and thus eventually wins over his desire to survive. A childhood so passionately felt in adulthood, Jude's history of violence extends into the future and is a reminder that the unwanted contents of childhood can reappear with force once one has "grown."

The novel's structure, in which present moments can only be explained by flashbacks to historical events, mimics the temporal structure of traumatic experience, wherein evidence of a disturbed past cannot be integrated and so it agitates the present. Because Jude has not worked through or gained sufficient understanding of his childhood abuse, he repeats its impressions in his adult relationships and fantasies. Abuse of children, in the many forms it can take, has notable consequences for their development and then, when not healed, for their future politics and sense of self. Jude, I suggest, struggles with the queer remains of his childhood. To make this point my analysis begins with rehearsal of Dina Georgis's theory of queer affect. For Georgis, as previously described, queer affects "arrive as surprise or interruption" (2013, 15) and "suspend knowable or teleological time and unhinge proper boundaries and habitual relations" (15). From Georgis I glean language with which to describe the fractal nature of time in the aftermath of trauma and the queer imprint of childhood distress left on adult relations. Following a discussion of her theory of queer affect, I spend time with psychoanalytic theories of trauma's impact on narrative in order to discuss how chronic abuse in childhood can move in excess of understanding throughout the life course. Then, I consider Jude's tendency toward self-harm, particularly his

# THE QUEER REMAINS OF CHILDHOOD TRAUMA   89

cutting of skin, as an attempt to produce a bodily referent for a history of abuse. His cutting becomes a somatic need; it is psychic suffering enacted through the stimulation of physical pain.

*A Little Life* is full of devastation, and my aim is not to redeem or placate its violence. Rather, I position Jude's self-harm as inquiry into the thresholds and appeals of pain. The style and structure of Yanagihara's narrative cannot articulate what a better future looks like for Jude, nor is that the author's aim. Rather, she narrates the retrospective temporalities of childhood and the affective intensities of living in the aftermath of abuse. Jude's ego is shattered by a history of sexual assaults. The psychic workings of queer suffering (both as a man who desires men and in relation to the affective excess of trauma) overruns his ability to continue. Despite an adulthood in which he is deeply loved, the force of Jude's difficult childhood is not extinguished, and he has trouble insulating himself from its harm. The collateral damage of his childhood means that there is not space in the symbolic order for the affectivity of his trauma or the consolation that might come from a romantic relationship. My reading of the text asks what is possible beyond narcissistic responses to another's pain, and in raising the question, points to the queer excesses of traumatic experience that are not reducible to language. In conjunction with chapter 2's consideration of the violence of war, my rumination on the novel provides a theory of childhood trauma that respects the enmeshment of private grief in social realms.

## A Queer Text/A Queer Life

Upon release, *A Little Life* became a bestseller and finalist for many top literary awards. Garth Greenwell, in a book review for the *Atlantic*, called Yanagihara's book "The long awaited gay novel" (2015) for its showcasing of same-sex desire and use of queer themes of melancholia, isolation, and melodrama. The novel follows the lives of four men who form deep friendships in college and then live in New York City, where they each attain professional success. Jude, a luminous university student who excels at pure mathematics and legal theory, becomes a successful litigator. Jude is nicknamed "the postman" by his friends: "We don't know what race he is, we don't know anything about him," explains one of his closest friends (Yanagihara 2015, 107). Though his body often invites questions about race, culture, and ethnicity, he does not satisfy them because he does not know his parents and is missing other biographical details that would provide the verification being sought. Malcolm, another of the four friends, is the son of wealthy parents who eventually becomes an internationally successful architect. J.B., who in college begins an artistic practice that involves making sculpture from Black hair, eventually has a solo show at the Museum of Modern Art (MoMA). And then there is Willem, an aspiring actor who becomes so famous that he can't move through the city with any sense of anonymity. Willem and Jude become fast friends upon meeting in college, and over the course of thirty years, fall in love. As Jon Michaud has noted (2015), while the novel tells the story of how four men meet and weave in and out of each other's lives for more than three decades, the ensemble of characters eventually falls away, and Jude's interior struggle takes center stage.

THE QUEER REMAINS OF CHILDHOOD TRAUMA    91

While all four men have large amounts of success in their careers, Jude's success uniquely requires a disavowal of a wider affective range due to the way his childhood casts a shadow over his adulthood. The intensities of his biography are hard to encounter, but his inner preoccupations cannot be cast aside because the abuse is a narrative substance that gives shape to his character. While others have deemed the novel "queer" for its construction of gay characters and themes, my reading of the text is interested in the queer ways that Jude's childhood haunts his adulthood. Arguably, it is not only his romantic love for Willem that produces queer affect, but also the remains of his childhood trauma. Said otherwise, in my reading, *A Little Life* is queer not just for its use of gay relationships and identities but for its narrative account of the queer affective remains of a violent childhood. The abuse's punishing control over the psychic and physical terrains Jude now traverses causes the circulation of queer affect. His past cannot be cast aside because it cannot be understood or justified. The violence of his childhood is in excess of understanding; thus it is a queer specter that haunts the present. Willem comes closest to knowing Jude's stories of childhood abuse, but despite his greatest efforts, he cannot close in on the aporetic space of his lover's trauma; its affects cannot be contained or concealed by his desire for Jude. The psychical activities associated with Jude's history of sexual and physical abuse cause him to insulate himself against another's love, a defensive response conditioned by a childhood in which his love was manipulated. Trauma's deferrals, where pain is shot into the future, works against Jude's ability to let Willem care for him.

Trauma—an event that causes the subject to react, through symptoms, its effect—causes a specific form of

92    THE QUEER AESTHETICS OF CHILDHOOD

incongruence between affect and reason. A traumatic event repeats itself in the subject's mind; not worked through it causes an incapacity to control when psychic debris, left over and made from the unplanned and often surprising event, will blend with reality. "What returns to haunt the victim" of trauma, Cathy Caruth theorizes, "is not only the reality of the event but also the reality of the way that its violence has not been fully known" (1996, 6). For Caruth, traumatic experience has an entrenched relationship to narrative forms of storytelling. She posits, "The story of trauma, then, as the narrative of a belated experience, far from telling of an escape from reality—the escape from a death, or from its referential force, rather attests to its endless impact on a life" (7). Indeed, Jude came close to death many times in his childhood and youth and though he escaped, he never vanishes the imprint these experiences leave on his subjectivity.

Throughout *A Little Life* we can trace the re-emergence of Jude's chronically traumatic boyhood through the ghosts he must confront as an adult. There are the ghosts of the men who sexually assaulted him, the ghost of the man who does this but also intentionally hits him with a car, and the ghost of a lover who beats him for using a wheelchair. Memories of violence drift in the liminal space between his childhood and adulthood; thus the ghosts of his trauma force an eruption to linear time. In *The Better Story: Queer Affects from the Middle East* (2013), Georgis discusses the need to "make contact with the painful ghosts that have changed us and defined what we say and what we do" (10). She writes, "As long as ghosts exist, the story is interminable, sketched and resketched from the unassimilated traces of experience and of being itself" (11). Ghosts, Georgis explains, "speak through affect which is not

# THE QUEER REMAINS OF CHILDHOOD TRAUMA 93

yet narrativized" (11). For her, this affect is queer. Queer affect is a return of memories that have no space in the social world. Queer affects, according to Georgis, are a "return to the site of abjections" (15) in which the ability to perform decorum is lost. When queer affect finds its way to the surface we are "undone by its force" (115). Jude's queer affects are the remainders of difficult childhood experience that survives into adulthood. Conceptualizing his subjectivity in this way helps to explain emotional entanglements between his childhood trauma and his adult feelings.

In the novel, Yanagihara calls Jude's ghosts "hyenas." The hyenas appear as cause for anxiety and are a reminder of a past that he can't escape. He imagines them gathering around his bed and whispering threats; they haunt him in his dreams and the moments when sleep can't settle anxiety. The content of his dreams is often unwanted experience that can't be discarded and thus returns. After intentionally burning his hand as a form of self-harm, Jude comes back to consciousness and is confronted by the hyenas: "When he wakes, he is on the floor, his head against the cupboard beneath the sink. His limbs are jerking; he is feverish, but he is cold, and he presses himself against the cupboard as if it is something soft, as if it will consume him. Behind his closed eyelids he sees the hyenas, licking their snouts as if they have literally fed upon him. Happy? He asks them. Are you happy? They cannot answer, of course, but they are dazed and satiated; he can see their eyes shutting contentedly" (578).

Jude's hyenas are residue of past events in the form of fantasy. He describes memories of his childhood as "a slight parting of worlds, in which something buried wisped up from the loamy, turned earth and hovered before him, waiting for

94    THE QUEER AESTHETICS OF CHILDHOOD

him to recognize it as his own" (570). Yanagihara continues
to elucidate how Jude's memories feel: "Their very appearance
was defiant: here we are, they seemed to say to him. Did you
really think we would let you abandon us? Did you really think
we wouldn't come back? Eventually, he was also made to rec-
ognize how much he had edited—edited and reconfigured,
refashioned into something easier to accept" (570). One might
argue that the agency of the preserved past, etched into the
ego, is the reason Jude cannot extinguish his memories or the
hyenas. The desired assimilation and optimistic refashioning
of memory are not so easily enacted or sustained and so,
rather than diminishing in strength, Jude's hyenas gradually
grow stronger.

The hyenas that haunt Jude make it difficult to trust
others because they are symbolic reminders of times he has
been hurt. "Ghosts are forceful because they have trouble find-
ing their referents. They lurk without attaching to an organ-
izing symbolic, but bump up against it," Georgis explains (22).
The novel's ghosts, in the imagined form of hyenas, are spec-
ters of traumatic experience that haunt Jude's development.
He was once warned by a social worker that if he didn't speak
about the events of his childhood soon he would never be
able to do so. Indeed, Jude's past becomes interior and calci-
fied. Despite being adored by many, Jude cannot verbally
share the depths of his suffering with others, and yet, he pro-
vides glimpses into his past in the ways that he holds others
at a distance and refuses to speak of his childhood. Jude is
ambivalent to the potential security offered in friendship
because he can't find comfort in collectivity after being so
deeply injured by others. Perhaps he refuses empathy
because it does not adequately leave space for his need for

self-enclosure. The gift of male friendships provide respite and an augmentation of melancholia but cannot alter the phantasmic reality of Jude's childhood experiences.

The appearance of his ghosts and the regressive plunge of his dreams raises questions about the relationship between trauma and eros. Sexual intimacy, even with Willem who loves him deeply, raises a taciturn and dreadful feeling. For Jude, sex is never pleasurable but a reminder of vulnerability and unwanted violence. The developmental history of his emotions appears in all sexual encounters: "Not having sex: It was one of the best things about being an adult" (Yanagihara 2015, 346). Insulating himself against another's love is a defensive response to a childhood in which giving love over to someone regularly resulted in immense loss. There are symbolic equations between Jude's childhood abuse, his adult suffering, and his inability to feel worthy of love. His childhood experiences of violence encrypt his mind and affective states, animating what Caruth terms "belated experience" (1996, 7). For Dominic LaCapra (2014), trauma "is a disruptive experience that disarticulates the self and creates hold in existence; it has belated effects that are controlled only with difficulty and perhaps never fully mastered" (41). As both Caruth and LaCapra explain, trauma's symptoms cause its subject to enact an unfinished event; the subject has survived the event but has difficulty making meaning from it.

Experiences of child abuse frame how the future emerges and create affective energies that sew the past into the present. The unforgiving and persistent impact of this abuse is caused by reverberations of the original violence. As I have been suggesting, trauma's consequences on the child's development can be severe. As he ages, Jude's flashbacks to the

96    THE QUEER AESTHETICS OF CHILDHOOD

events of his childhood increase in frequency and intensity. His childhood abuse increasingly returns against his will, shattering his ability to trust others. "What one returns to in flashbacks," Caruth suggests, "is not the incomprehensibility of one's near death, but the very attempt to claim one's survival" (1996, 66). In Jude's case, though, survival is not always desired. When the flashbacks and visits from hyenas become more frequent, he taunts death, calling it into proximity. His acts of self-harm are efforts to negotiate the temporal modalities of trauma. In the next section I consider Jude's acts of self-harm for their psychic and emotional purposes. Due to trauma, Jude has difficulty completely inhabiting the present because his past causes feedback that intrudes on the contemporary moment. Self-harm, mostly in the form of cutting skin, offers a way to live alongside tragedy.

## Cutting Skin

Soon after birth, Jude was left to be found. His discovery by a Catholic sect of monks then leads to his upbringing in a monastery. While there he is physically and sexually abused and begins to act out in the form of "tantrums." Revolts against a lack of protection from pain, the tantrums are an accusation against a world that has not loved him enough. Just before his ninth birthday, Jude is convinced by Brother Luke, one of the monks, that he should join him and run away from the monastery. Eager to leave, they sneak away together quietly in the middle of an early spring night. In a review of the novel for the *New Yorker*, Jon Michaud (2015) describes the event and the narrative that surrounds it: "Brother Luke promises Jude that they will go and live together as father and son in a house in

# THE QUEER REMAINS OF CHILDHOOD TRAUMA    97

the woods, but the reality of their years on the road is much, much grimmer. Eventually, Jude is liberated from Brother Luke, but by then he appears to be marked for sexual viola-tion. 'You were born for this' Brother Luke tells him. And, for a long time, Jude believes him."

It is Brother Luke who teaches the boy to cut himself as a way to deal with anger and emotional hardship. After watch-ing Jude intentionally throw himself against a wall following a particularly violent sexual encounter with a man, Brother Luke offers him a razor blade and alcohol wipes for cleaning the wounds. Jude had found throwing his body against the wall and the "freshness of the pain" restorative (Yanagihara 2015, 474). In Brother Luke's offering of a more organized mode of self-harm, the reader gets a small glimpse into the likelihood that Luke has suffered his own traumas and has developed a system for managing their symptoms. Jude learns to craft a care kit, always on hand, with objects used for the dual work of harm and aftercare. Even after Brother Luke loosens control over his life, Jude continues to cut himself as a way to deal with the accumulation of incomprehensible violence. A lack of ther-apeutic resources inhibits mourning and increases vulnerabil-ity, which is temporarily soothed by self-harm.

In *The Psychic Life of Power: Theories of Subjection* (1997), Judith Butler describes some of the psychic machinations of child abuse: "Debates about the reality of the sexual abuse of children tend to misstate the character of exploitation. It is not simply that a sexuality is unilaterally imposed by the adult, not that a sexuality is unilaterally fantasized by the child, that the child's love, a love that is necessary for existence, is exploited and a passionate attachment abused" (78). Should we follow her line of thinking, a child such as Jude, who has

98    THE QUEER AESTHETICS OF CHILDHOOD

not been provided with a sufficient foundation of care, loses the capacity for affective discrimination. Butler continues: "If the child is to persist in a psychic and social sense, there must be dependency and the formation of attachment: there is no possibility of not loving, where love is bound up with the requirements for life" (8). And so, the abused or neglected child seeks love where it seems to appear, even if that expression of affection is tainted by danger and hate.

Jude's cutting articulates a wish to commune with what Anna Walker calls "the dissociative experience of trauma" (2015, 317). Self-harm, understood psychoanalytically, testifies to the ongoing need to abate suffering even while purposefully injuring the body and inducing somatic pain. Drawing on notions of skin as the border between inside and outside, affect, and representation, Angela Failler (2009) extrapolates on the relationship between self-harm and self-care:

> While it may seem paradoxical, inflicting a wound upon one's own skin may create an occasion to care for the self, whether by cleaning or subsequently trying to secure the wound or merely by witnessing the wound as it appears and begins to heal. The self-inflicted flesh wound, in other words, makes an opportunity to recognize and be with one's own pain when perhaps no one else did or could. It is in this sense that self-harm not only represents physical trauma but it is an attempt to compensate for it, that is, an attempt to compensate for the traumatic loss of a resilient enough psychic boundary. (16)

For Failler, self-harm is citational practice because it renders space in the social world where pain would otherwise

THE QUEER REMAINS OF CHILDHOOD TRAUMA 99

remain inexpressible. "When self-harm is defined by its violence," she explains, "what is lost is creative agency and meaning for the subject that lives in the aftermath of trauma" (15–16). Jude's history of traumatic experience causes a unique adhesion between past and present; the constant feedback of trauma instigates an intrusion to the contemporary. Jude learns to make incisions in his skin that help to control and externalize his pain. In his penchant for self-harm, he socializes the affects of his trauma. The psychic function of the open wounds he creates on his body is to allow an expression of grief that has an authoritarian presence in his interior world. Jude continues to cut himself for the remainder of his life; his physical acts of self-reproach are traced in the psychic turns of emotional life. His place of work, where he is a high-powered litigator, is a site of refuge because of the distraction it enables. But even there, the spectral elements of his past begin to appear, and he soon arrives to work with deep cuts to his skin.

With scars and wounds running down his arms, others are sometimes able to notice his practice of self-harm. Because he does not cut with calculable interest but, rather, an underlying world of object relations, no one is able to convince him to stop. Jude's cuts are difficult to bear witness to. They are posttraumatic symptoms of abuse and communicate some of the affective dimensions of loss. To observe his cuts leads one to wonder if and how it is possible to live alongside memories of child abuse. His wounds are tied to a compulsion to symbolize the excess of meaning that runs beyond his ability to control history's re-emergence, and through his incisions he makes psychically available what has not been healed emotionally. As Michaud explains in his *New Yorker* review, "the cutting is both a symptom of and a control mechanism for the

## 100    THE QUEER AESTHETICS OF CHILDHOOD

profound abuse Jude suffered during the years before he arrived at university." Jude's self-harm began as a primal call for help, but in the end, it brings him closer to a desired death. To love Jude now is not to simply convince him to stop cutting but to understand his need to do so and to be *with* his trauma rather than repress it. Embedded in his desire to cut is a history of abuse so complicated that it cannot be done away with to please another. Jude's eventual suicide is a release from pain. It leaves one to ask what form love and friendship could take that would integrate Jude's trauma and cultivate an empathic witnessing of his childhood wounds.

### Temporal Ruptures and Affective Correlations

*A Little Life* is an aesthetic text in line with this book's theoretical endeavors because its lesson is that there can be no final breaking-off from childhood. Jude's childhood increasingly returns against his will. From Yanagihara's novel we are reminded that the consequences of violence on the development of self can be severe. As he ages, Jude's childhood and adolescence do not grow distant but rather, closer. The sexual abuse he experiences as a child legislates him to an adulthood of pain that entrenches history in the present. The intersubjective dynamics of Jude's childhood abuse reappear in most other symbolic realms. Importantly, in the novel, the psychical activities associated with childhood abuse are given aesthetic elaboration that does not seek to repress through a quick cure but rather, understand how the past retains affective intensity in the present. And yet, there is also the reparative potential of re-narrating history so that its violences are better understood. I have made the case that *A Little Life* opens

THE QUEER REMAINS OF CHILDHOOD TRAUMA 101

up inquiry into how the past is transmitted to the present and in this case, how difficult childhood experience reappears in adulthood. An inference from another time and place, Jude's childhood abuse is correlative to a melancholic adulthood.

Subservience to the law of childhood innocence often requires ignoring the anger and resentment that come with trauma. It restricts notice of children's active engagement with and subjection to violence. As *A Little Life* demonstrates, caring effectively for childhood trauma requires a model of growth and development that holds open space for the nonlinearity of trauma's returns. Allowing trauma's returned content to find expression is a mode of help that can be offered by concerned adults in an effort to be with children as they regain trust in a failing world, rather than repress its horrors. In this chapter, queerness has helped to name the affective reservoir of feeling, desire, and violence not successfully repressed in Jude's efforts to grow up. A traumatic event's ensuing damage requires an innovative therapeutic, pedagogical, and methodological approach. In asking how a child can love a world that has shown its inability to offer protection when it is most needed, the novel insists that childhood is inextricable from adulthood experience.

# 4

# Reparation for a Violent Boyhood in *This Is England*

When a man realizes there is grief behind his anger, and
that what he felt when he heard this or that is not the
passionate affect that possessed him at the time, but
something finer, how does he do so? He remembers.

–Teresa Brennan, 2004

For a child who loses a parent, the capacity to mourn loss is
integral to survival. The event of a parent's death requires
learning to live amidst the specter of loss formed from the
traumatic severing of a loved one. For most, this loss undoes
a sense of security and fragments the emotional econo-
mies and symbolic systems the child is in the process of con-
structing. As this book has been arguing, the symptomatic
afterlife of a difficult childhood can contour adolescence and
adulthood if its affective dynamics are not worked through.
The affective intensities of living in the aftermath of child-
hood loss cause disruptions to the process of "growing up"
and frame how the child's future emerges. One might say
that trauma queers childhood development. An inference
from another time and place, the queer remains of difficult
childhood experience can reappear with searing intensity.

## REPARATION FOR A VIOLENT BOYHOOD    103

Because it unhinges borders between past and present, and disrupts temporal progressions between then and now, the experience of loss in childhood can be encrypted in the subject's future. Thus trauma, an event that can survive all intentions of eradication, leaves a queer trace on subjectivity. Should children not be given adequate space to mourn or air anger, which is often the case when social constructions of childhood assume innocence and resilience, there is not space in the social or symbolic order for the queer affectivity of childhood trauma.

This chapter turns to Shane Meadow's 2006 film, *This Is England*, because it calls attention to the trauma of losing a parent, the residual state of grief caused by this loss, and the value of mourning.[1] In narrating a child's psychic interiority after the death of a father, Meadows cautions against what can happen to development when the expression of grief and rage is inhibited. The child protagonist in *This Is England* does not possess a queer identity. Rather, my engagement with the film emphasizes the queer remains of loss that the child must deal with. The film's protagonist is a boy, approaching adolescence, named Shaun Fields (a pointed revision of the filmmaker's name). Shaun's father has recently been killed fighting in the Falklands War. Shaun is a lonely child who lives in working-class Exeter in the early 1980s, a city bruised by economic recession and deeply impacted by resultant miner's strikes and protests. The loss of his father leaves a tear in his emotional world, and violence is temporarily used to cover over, melancholically, vulnerability made from this loss. Shaun is rendered capable of extreme violence and plays a role in a movement for the revival of the "Englishman," which proposes immigrants return "home" so as not to take jobs away from

"deserving" men. He has his first girlfriend, his first encounter with drugs, and learns to terrorize other children. *This Is England* stages the story of a child whose hate and anger are a desperate attempt to restore a lost object. The child who has recently lost his father propagates a violent masculinity that is given intensity from an inability to grieve. The film explores how children attach their fantasies of omnipotence, subjugation, guilt, and reparation to the larger historical and cultural events that surround them, and how children can play a foundational role in the violence of white supremacy.

This chapter explores the representation of childhood grief and anger in *This Is England*, and the affective scene of watching the film, in order to consider how the return to a violent history, individual and social, can loosen something repressed in both an individual and a nation. Because of its careful representation of the psychological underpinnings of a child's hate and phobias formed after the death of a parent, *This Is England* is a powerful tool for thinking about the impact of mourning on the child's formation of self. With reference to psychoanalytic accounts of the imbrication of social and psychic life, my analysis considers the symbolic labor involved in Shaun's concerted effort to belong and to be understood. Suggesting that there is insight to be gleaned from Meadows's aesthetic treatment of grief, I read the film as an elegiac meditation on the psychic terrain of unbearable childhoods not extinguished with the advent of adulthood. An invitation into the emotional space of a young life altered after the traumatic loss of a father and the affectivities of loss obfuscated by a feigning of confidence, *This Is England* offers a pedagogy of mourning that emphasizes the psychical and symbolic act of reparation.

## REPARATION FOR A VIOLENT BOYHOOD    105

*This Is England* would not typically be categorized as a queer film. It does not take up LGBTQ themes or people, and yet its child protagonist struggles with the queer remains of his father's death. In the film, it is not sexual identity that produces queer feeling, but the affective remains of childhood trauma. Drawing the film into a queer archive of childhood allows notice of Sean's struggle with the queer affective remains of his father's life. The child is fractured by the psychic workings of suffering that exceed his ability to make meaning from his father's death, the force of which becomes concentrated in a son's pain and leads the child toward violence and aggression.[2] Indeed, on offer in the film is an ensemble of masculinities conjured via the unworked-through histories of racism, war, and colonial pursuits that constitute political terrain in contemporary England. Meadows's narrative suggests that violent masculinity can result from the repression of vulnerability. He also raises inquiry into how affective attachments to racist nationalisms are, in part, psychic strategies that foreclose vulnerability. As discussed in chapter 1, Anne Anlin Cheng (2001) has made a similar point in relation to whiteness and melancholia in America, and the constitutive force of racism in American values. My consideration of the psychic underpinnings of hate do not work on behalf of sympathy for white nationalists, but rather, are driven by the potential to address racism in child development. Of course, there is also the question of gratification drawn from racial inequality and the structural privilege of whiteness that allows anger to be funneled toward racialized immigrants. The textures of the child's outbursts and violence are informed by his whiteness. The boys and men in *This Is England* offer examples of how gender presentation is

106    THE QUEER AESTHETICS OF CHILDHOOD

determined by a complex network of libidinal ties, conscious desires, and unknown but deeply felt fantasies of mastery over loss. Because there is a tendency to sentimentalize the experience of childhood, the film's rendering of a boy's searing violence is significant. In its depiction of how a child can become monstrous after the loss of a loved one, and benefit from white supremacy, the film is a resource with which to consider the feelings of conflict and loss that create both injured boys and injurious masculinities.

In this chapter, with the help of the film, I consider how an acknowledgment of gendered and classed subjectivities can strengthen the efficacy of theories of child development. Relatedly, I contemplate a question that has been central to this project: What becomes of a child's psychic pain and social alienation when they are not cared for? The film helps to aesthetically elaborate how a traumatized child without support is likely to become an adult in pain. Without support and resources, childhood trauma leaves a state of grief that has a forceful presence in the adult's libidinal economies of social and political crises. I begin to make my case by returning to Melanie Klein's theory of guilt and reparation, which relies on her clinical observations of children's interminable battles to tolerate ambivalence and to synthesize good and bad objects. The enduring value of Klein's insights into children's development is demonstrated through a discussion of her notion of "the depressive position" (1935, 1998) in relation to Shaun's grief. Klein's theory helps to explain Shaun's difficulty in integrating the loss of his father and forge a reparative position that does not turn away from pain but, rather, integrates it into the self. Shaun, I will suggest, cultivates a violent masculinity as a result of repressing a loss too difficult to bear, a

reaction to the shattering effect of grief that is common among boys who are not supported in expressing vulnerability. In addition to reading the film through Klein's psychoanalytic theory of child development, I offer a Winnicottian treatment of the film as transitional object useful for its pedagogical treatment of the relationship between boyhood, mourning, and violence.

Both Klein and Winnicott have acquired currency in contemporary theories of film aesthetics (Gordon 2010; Lebeau 2014; O'Pray 2004), but the line of inquiry they open here is also to do with the emotional center of creating and becoming educated in theories of child development. The work of mourning is hard to conceptualize; its enigmatic qualities and temporal discontinuities are not easily describable. And yet psychoanalytic studies of childhood offer a persistent attempt at understanding and narrating the psychical activities associated with coming to terms with loss. From within this tradition, I describe *This Is England* as an aesthetic resource where one can observe how the psychic structure of trauma finds expression. I proceed from this premise to ascertain some of the specific lessons offered by Meadows, such as racism as a developmental inhibition and the need to offer children an environment that facilitates mourning. Film, as an example of creative fiction, offers an aesthetic experience in which "disavowed affects of relationality: loss, conflict, and pleasure" are expressed and held (Georgis 2013, 77). Though *This Is England* does not provide a clear psychological map of recovery for childhood trauma, it does demonstrate the importance of mourning to the child's psychosocial development and film's capacity to aesthetically elaborate a child's interiority.

FIGURE 3 Film still from *This Is England*.

## Reparative Urges and Creative Expressions

We are introduced to Shaun, the film's protagonist, as he sits in his bedroom, with walls that are crumbling and paint that is chipped, staring longingly at a picture of his father and listening to Margaret Thatcher's speech on the last day of her first term as prime minister. Thatcher's words, captured and disseminated by BBC radio, form a significant portion of the film's soundtrack, aiding in an explanation of how many of England's voters were seduced by her proposals to limit social welfare and labor unions in favor of economic deregulation and privatization. Thatcher's speeches form the backdrop for scenes that display intimate and quotidian elements of the characters' lives, helping to elucidate the private casualties of national problems and to give context to the phantasmic formations that underwrite the nation. *This Is England* is an archive of working-class history in England, and the racial injuries caused by British nationalism. The affective blow of

## REPARATION FOR A VIOLENT BOYHOOD 109

the film not only results from the child's strife but also from the injuries caused to the immigrants and diasporic communities that become reviled objects of an emboldened nationalism that grows within white working-class communities. As racist nationalisms continue to agitate social life in England, the film remains valuable for its aesthetic elaboration of some of the psychological and affective issues that drive hate.

In his grief, Shaun is seduced by the striking aesthetic of skinhead culture and its promise of strength, and then becomes involved in the right-wing nationalism that stains some iterations of what it means to be a "skin."[3] *This Is England* depicts how a community of white, British men and boys clung to a nation, like a parent, while repressing vulnerability in relation to masculinity, war, and unemployment. Shaun feels thrust apart after the death of his father and too quickly turns away from his loneliness and toward an attempt to find fortification in the form of skinhead culture and its performance of virility. In choosing to feel infallible rather than vulnerable, and in his defensive posturing, Shaun resists understanding how his loss has been both transformative and calcifying. Rachel Hurst suggests that "feeling lonely is a step away from loss and a step toward integrating loss into one's life" (2009, 36). The difficult work of reparation involves facing loss, either known or felt, and integrating it into the core of subjective life. In offering a pedagogy of mourning and contemplation of the emotional work central to that condition, the film holds open space in which to consider why a child's violence covers over his inability to trust that he is loved.

A desire to understand how to help grieving children return to a state of ambivalence, in which they confront despair and feel a sense of hope, leads me back through a

110    THE QUEER AESTHETICS OF CHILDHOOD

reading of Klein's theory of reparation. In 1935, Melanie Klein began to conceptualize the "depressive position," a period of psychological growth in which one forms ambivalent feelings toward an object that they were compelled to either love or hate, admire as good or disdain as bad. As I suggested in the first chapter, reading Klein and her animation of the infant's psychic dramas presents a way to think about and acknowledge how aggression and negativity productively vacillate with good affects. The infant does not yet realize that the mother's breast that sometimes denies gratification and at other times satisfies wishes belongs to the same object (the first object, the other). Klein suggests that the child is led, in phantasy, to damage the image of its mother, for sometimes she withholds food and affection when it is desired. The infant's voracious greed comes to result in feelings of guilt and attempts to repair the damage done in worlds of phantasy. To reach the depressive position, where once the child felt compelled to divide its objects into pieces and to keep distances between persecutory and idyllic objects, it must now repair damage waged against the other who is at the same time loved. Klein explains: "The ego feels impelled to make restitution for all the sadistic attacks that is has launched on that object. . . . At this stage of development loving an object and devouring it are closely related" (1998, 265–266).

For Klein, the ability to symbolize a relationship to the loss of a loved object or ideals is reparative, and the urge to repair hate becomes a powerful force in all creative activities (Hinshelwood 1989, 398). In writing about Klein's depressive position, Eve Sedgwick points out that the romanticized gloss over ideas and objects to which we form passionate attachments must be removed (2003). Sometimes, the set of ideals

## REPARATION FOR A VIOLENT BOYHOOD    111

that one holds near must be relinquished in order to recognize one's ability to tell a nuanced story. For Klein, the ability to symbolize a relationship to the loss of ideals was reparative. Klein's theory of guilt and reparation is useful in considering how, after the death of a parent, hatred may subsume a child, and the necessity of reaching a state of ambivalence is a psychic achievement required to rebuild optimism. *This Is England* offers a narrative in which to observe a child struggling against tendencies to split the world into good and bad and to reach the depressive position. Rather than embrace the vulnerability that comes with loss, after the death of his father Shaun reconstructs himself as a skinhead and shields himself from loneliness and ambivalence through the acquisition of membership in a gang. Shaun maintains an affective connection to loss but, without resources that could return him to his ambivalence or help him to reconcile with a world that can take away what he loves, he turns to violence as an act of self-preservation.

After his father's death, Shaun's isolation is temporarily amended by an invitation to spend time with a group of young men who, though much older than he, will become his friends. Though at first suspicious of their intentions, Shaun is eventually able to relax into the friendship and hopes that it will yield a sense of security and collectivity. His grief is temporarily repressed and sealed off from conversation, as his initiation into the group lends him a sense of social belonging. Shaun is enchanted with the group's leader, Woody, remaking himself in his likeness and adorning himself in the sartorial markers of skinhead culture. Alienated by other children, Shaun finds community within a group of men who are also emotionally broken and pleased to have a boy to mentor.

Seeking substitutes for a lost object, the drive to reclaim an originary attachment intensifies Shaun's desire to fit in. Jacqueline Rose (2007), drawing on Freud, explains that "We love the other most, or need most to be loved by the other, when—from that other and from ourselves—we have the most to fear" (68). The grief and fear induced by the death of his father help to explain the allegiance Shaun has to Woody. Rose warns that the love of a leader is "a precarious gift" (67) and that in each identity purchased through membership to a group there is a fault line (13). The precarity of the group is that it is a screen on which an individual projects need. The gang of friends to which Shaun now belongs becomes a sublimating force that seals off the pain of mourning but does not permanently erode pain or insecurity.

Soon after Shaun finds belonging and social protection, a man named Combo returns from a prison sentence and seeks re-entrance into the gang. Combo is dangerous and callous, imagining himself as an insurgent whose political purpose is to help Britain rebuild a relationship to its imperial history while dismantling the cosmopolitan endowments left in its wake. His anti-Black politics and unrelenting hatred for immigrants cause a fracture in the group and, despite impassioned requests from Woody, Shaun is convinced by Combo that by fighting for the nation he will avenge his father's death. The ideological persuasion of Combo's mentorship and his stagnant hold within the paranoid position works to give purpose to Shaun's grief. The child switches allegiance in order not to betray his father's memory, and Combo ousts Woody as his patriarch. Woody's was a more benign exploitation of the boy's dependence, whereas Combo uses Shaun's tendency to idealize for the purposes of his paranoid fantasies that

## REPARATION FOR A VIOLENT BOYHOOD     113

immigrants will take from him what is inherently deserved. The boy thrives in the economy of aggression and hate that Combo creates. Under the coercive force of social belonging, Shaun is initiated into a world of racist terror, learning to steal from and threaten those who aren't white. Shaun's grief drives him to act-out and to seek expression of loss in acts of social hatred; his unmourned loss turns not only against himself but also against others. If, as rhetorics of childhood innocence would have us believe, all children are well-meaning and inculpable, then Shaun's queer difference is in part derived from his ability to be vile.

Shaun, Combo, and their clique displace their anger and their economic exigencies onto immigrants, finding the South Asian man who runs a convenience store worthy of robbery and a threat of death by machete. Given their resentment that the store-owner has had a (small) amount of success in acquiring capital, the convenience store becomes a material elaboration of human relationality in the decomposition of the romance of the empire they hold in esteem. Combo and his gang rage against modes of capitalist accumulation that are not available to them. The small store becomes a material site on which to enact the social and psychological phenomena that license racial hierarchy. In the terror and the corrosive impact of racial violence they cause, the white men's shared illusion of mastery is socialized, and the boy's subject formation impacted. The violence can't compensate for his loss, though, and therefore never quenches his appetite for destruction. The Black "countercultures of modernity" (Gilroy 1995) are evacuated from the narrow history that Combo's strain of skinhead ethos espouses. Combo's "love of aggression takes the form of racist fury ('it's like looking in the mirror'): the

cliché carries full force in mapping out one possible future for Shaun" (Lebeau 2013, 887). Without another way to work through his grief, Shaun believes that Combo will help him soothe the emotional topography of loss that has left him vulnerable. The more monstrous the boy becomes, the more proud his mentor is of him.

With the group's division, Woody on one side and Combo on the other, Meadows stages the tensions between emboldened nationalists and antiracist skinheads in Britain in the 1980s. Dick Hebdige has explained that "skinheads drew on two ostensibly incompatible sources: The cultures of the West Indian immigrants and the white working class" (1979, 55). Meadows narrates how in the 1980s, far right-wing politics began to infiltrate skinhead communities that were previously sites of resolute multiculturalism and transcultural exchange. Within skinhead communities, white-supremacist nationalism began to outweigh alliances between racialized laborers and white, British working-class skinhead men who held deep respect for ska music and the blues they were introduced to by the Jamaicans they met in factories and shipyards. Screening the film in the contemporary moment allows for consideration of the psychological underpinnings of the fervent (but also more insidious) forms of nationalism that continue to persist in England and consideration of children's subjectivities that are formed in proximity to them. Meadows's desire to aesthetically represent the mixed feelings of attachment and shame with which he calls Britain his home is palpable in his rendering of the skinhead movement, a community he describes as important to his own sense of power as a boy.

Combo's hatred and aggression belie a store of pain built up inside of him, presumably from his own losses. His

character offers an example of what problems arise for the self and then others when unmourned loss finds social expression. Combo is central to the narrative because in him we witness a potential future for Shaun should the child not find reparation for his suffering. The emotional excitement Combo gains from racist violence and his restless fantasy of returning England to an imagined past in which he rules provide insight into his broken interior world and history of attachment, resentment, betrayal, and abandonment. A Kleinian treatment of Combo's anger might suggest that his tendency to split the world into good and bad, particularly along racialized lines, has to do with an inability to find needed emotional rest in the depressive position. He creates the enemy he needs to unleash anger upon. Part of Combo's healing may be that the nation must become a whole object, good and bad, a geography and psychic formation that he is ambivalent toward. His reverence to the nation and propensity for splitting have precluded and damaged his ability to mourn. His confused longing and obdurate attachment to a fantasy of mastery seek to repair a difficult past, and perhaps, his own childhood traumas. In Combo, we are given a demonstration of what could become of Shaun. Reciting his injuries, and replaying the psychic structure of events that has made him enraged, Combo tries to teach Shaun that through political loyalties he will fortify himself against vulnerability. Together, they retreat to the nation as a holding place for their rage and defend against the difficult work of reparation.

In *Postcolonial Melancholia* (2005), Paul Gilroy leads us back through a reading of Freud's *Civilization and Its Discontents* (1930/2002) to understand how a group's cohesion and

116    THE QUEER AESTHETICS OF CHILDHOOD

identification with a nation-state can rely on the mutual hatred for the other. Gilroy writes, "I would like to align the critical exploration of racial discourse and its consequences with what I take to be the guiding spirit of Freud's advocacy in pursuit of the anatomization of cultural groups" (65). With Freud, Gilroy is suspicious of the "pathology of cultural communities"; he explains that Freud is "calling, in other words, for a particular form of inquiry directed at the psychological poverty and pathological character of groups that understand their collective life and fate on specifically cultural terms" (65). In line with Gilroy, we might acknowledge that Combo's and Shaun's nationalism has an emotional and psychological economy and that specters of a troubled past cling to Combo's needs for followers in the present. Through Shaun, Combo has the chance to remake a family, to recuperate a lost childhood and family ties. In collective identity and a shared hatred for immigrants they hope to fight off a fear that they are not loved. The "emotional ties which bind subjects en masse," according to Jacqueline Rose, "are precisely the experience of being loved; or to put it in more clichéd terms, not what I give you, but what you give, or do for, me" (2007, 67). The imagined love that is received from belonging to a political group may help to substitute for other losses or defend against knowing the depth of one's emotional isolation. Georgis (2013) explains that "the power of nationalist movements is that they guarantee belonging and therefore, security, but only in exchange for obedience and loyalty to the imagined nation and its paternalistic figureheads" (72). She continues, "Under this contract, individuality and creativity are curtailed" (72).

In *This Is England*, Combo and his followers' racist nationalisms, including those espoused by Shaun, have an emotional

economy and are demonstrated to be, in many ways, a reactionary defense against fragility. In the next section I read two scenes from the film that emphasize the psychological antecedents of a broken masculinity in order to show the danger of stalling mourning and thus, creativity. The aim is to think together the subject formation of a violent boy and the subjection caused by a violent man. In considering children's rebellions against adults' rules, Winnicott proposed that the child's and adolescent's delinquency should be recognized as a sign of hope (1987). Jen Gilbert (2014) explains Winnicott's theory: "Risk-taking may be done in the name of hope and be an effort to reestablish the grounds of possibility for the self, but the actions of youth are not always hopeful. The paradox is that recognizing the tremendous psychical work of making a self in adolescence means seeing the spirit of hopelessness in action while insisting that risks that put the self or others in danger are not hopeful" (41). On the cusp of adolescence, Shaun's ability to develop symbolic capacities is stalled by a desperate hope that he will find safety and comfort in the totalizing power of a father figure. In his violence, Shaun may be expressing hope for his father's return, but, as Gilbert would suggest, his actions are not, paradoxically, hopeful. His risk taking intends to harm others. He acts out and learns lessons in delinquency, rebellion, and violence from Combo, a man who offers the audience a glimpse of Shaun's future should he not mourn or repair the past. Combo's fantasy of a ruined nation overtaken by racialized immigrants who steal employment from him reveals a relationship between his insecurity and injurious masculinity.

## Melancholic Masculinities

In a critical scene in the film, Combo waits for Lol to pass on her way to work, and when she does, pleads to speak with her for five minutes. She declines but under persistence and pressure, gives in to "two minutes." Combo then explains, softly, that he can't stop thinking about her and the "beautiful" night they spent together before he left. She is upset by his comments and tells him it was not beautiful but rather, the worst night of her life because she was young, drunk, and unable to consent to his sexual advances. "It wasn't beautiful?" Combo asks in honesty as Lol swiftly gets out of the car and walks away. He begins to quiver, to cry, and to violently bang his head against the steering wheel. His pain is born out of the recognition that she never loved him, and the knowledge that his expression of desire was experienced as violence shakes him deeply. Combo's affective and bodily reaction to the exchange displays a barely suppressed self-contempt. His virulent masculinity, configured through the pain of disappointment, crumbles as he comes to terms with Lol's admission that she was violated by him. Combo's nationalist mythologies defend against brokenness and for him, the nation-state has become a passionate site of attachment, a transnational object onto which he can project desire for inclusion and love. As he cries with the affective force of an upset infant, the audience is witness to hints of profound emotional disruption that originates long before Lol's presence in his interior world.

In the second scene that concerns me here, Combo, in an attempt to soothe himself after his encounter with Lol, approaches a character named Milky, who is Black, in search of marijuana. The viewer arrives to the scene anxiously, at this

REPARATION FOR A VIOLENT BOYHOOD    119

point familiar with the depths of Combo's violent tendencies. Milky provides Combo with what he is in search of, and soon they are high and in Combo's apartment, along with Shaun and other friends, relaxing and seemingly having fun. The soundtrack to the skinhead movement plays in the background: ska, reggae, and soul, an outcome of "the rhizomatic, fractal structure of the transcultural, international formation" (Gilroy 1995, 4) of the British nation. Combo begins to ask Milky about his family and childhood, and the room quiets as Milky describes the loving environment that he calls home. Hearing about his large family, with cousins, aunts, and uncles who share food and resources makes Combo visibly upset. That Milky has a loving family and was provided with a happy boyhood is not only an inconvenience to Combo's dangerous fiction of Blackness as inhuman, it is a profane disruption to his sense of self and the racial "truths" in which he deposits his anxieties and disappointments.

Combo cannot make the conceptual adjustment needed to receive this information about Milky's secure place in a loving and large family. His incapacity to regard Milky's happiness and social ties as humanly acceptable, and Milky even, as human, stir a violence in him. Klein may explain this as an effect of projective identification, an unconscious phantasy in which Combo's brokenness, trauma, and history of losses is not reconciled with individually but split off from the self and ascribed to another. In projective identification, the subject desires or needs to expel interior feelings of badness or pain onto the other, thereby externalizing helplessness, confusion, or vulnerability. Milky's humanity is irreconcilable with Combo's emptiness, and his power is negotiated by force, as he begins to beat Milky to a point in which the audience

120    THE QUEER AESTHETICS OF CHILDHOOD

has trouble discerning whether he is dead or alive. Shaun is witness to the scene, and when Combo's anger breaks and he is able to comprehend what he has done, he instructs Shaun not to cry, to "be a man." It has taken another traumatic experience, the witnessing of Milky's near death, to return to the work of mourning. The child bears witness to Milky's racial trauma, both emotional and physical, and is undone by it. After being spectator to the almost deadly repercussions of Combo's wrath, Shaun is restored to his grief and his inhibited mourning process is released. The beating causes a needed rupture in the affective hold Combo has on him. Shaun must do away with the ideals adopted from Combo in order to begin the creative work of mourning and reparation. It is collective failure that the boy is without a good enough environment in which to work through his grief, but Combo uniquely aided in the severe restrictions placed on the child's ability to mourn. Meadows insists that it is the environment, not the individual child, that is insufficiently resilient.

## Monstrous Child

Thinking against impulses and tendencies to reify gender binaries, my treatment of the film has not suggested that boys, men, or masculinity are more inherently tied to violence. But, in a culture that does not create a venue for symbolizing aggression and supports gendered stereotypes, a boy who experiences a traumatic loss may turn to violence to express pain. *This Is England* creates an opening into a conversation about what can happen when the continuity of a relationship between care provider and cared for, in this case father and child, is suddenly broken. Thus the film offers what Winnicott

## REPARATION FOR A VIOLENT BOYHOOD       121

calls "a potential space" (1971, 2005) for making new meaning from the residues of loss on a child's development. Shaun's instinctual loving and hating are complicated when his father is abruptly killed. Without a sufficient space in which to aesthetically and emotionally represent hostility, he is more volatile. In Meadows's film, the profound consequences of this lack help to explicate the psychic antecedents of violent masculinity. Winnicott believed that "it is creative apperception more than anything else that makes the individual feel that life is worth living" (2005, 87). For him, a point of interest was where the child's creativity had gotten stuck. If the work of mourning involves a creative reconstruction of self, then Shaun's reconstruction heads in the wrong direction. Judith Butler suggests that mourning involves "submitting to a transformation" (2004, 21) and agreeing to participate in a world that has been altered by loss. Shaun does submit to a transformation after the death of his father; he becomes a skinhead whose boots and suspenders are armor against a world that can take away that which he loves the most. This transformation does not enable the creative work of mourning, which involves learning to face what lessons about oneself are "hiding in the work of loss" (Butler 2004, 22). For those that work with children or study childhood, the film offers a reminder of the importance of creating a facilitating environment for the child's aggression so that children may express an inner world of grief and resentment rather than attaching anger to undeserving objects.

Shaun becomes monstrous under the tutelage of Combo, a man so damaged that he cannot control his violent aggression. Together, they create a world where violence against others is the answer to internal strife. Both Shaun's and

Combo's monstrosity evokes an inner world of aggression and devastation and presents the audience with a representation of how cruelty can be a symptom of insecurity and internal persecutory destruction that projects onto others what is undesirable from the inside. Each time they feel sadness, terrorizing another becomes an act of omnipotent destruction that defends against loss. As the child inches toward the borders of adolescence, he learns to substitute nationalism and Combo for the loss of his father and undergoes the process of disillusionment that marks growing up. The child's violent reconstruction of external reality is an attempt to diminish psychic stress and to control anxiety. He is operating from within what Klein may deem a paranoid–schizoid position. The child's violence is an accusation. In an effort to stave off despair and anguish, he and Combo split the world into good and bad. This rigorous and grotesque splitting works to dehumanize immigrants. In order to belong to Combo's gang, all members must remain vigilant to the fractal nature of this splitting, otherwise be evicted from the group. In suggesting that facing the psychological dynamics that sustain idealization and hate, Meadows shows the potential for his protagonist to work through injury and begin the difficult work of reparation. At the end of the film, Shaun has exited the gang, but the force of his participation is not extinguished. Some of Shaun's queer affects will be the remainders of his father's death. His constant struggle will be to confront the ghosts of this loss and notice their impact on the psychic turns of his emotional life.

With *This Is England* Meadows has given the field of child studies a collective site for thinking and learning about racial violence, histories of British nationalism, masculinity, and

grief. My interest in Meadows's film analytically, methodologically, and pedagogically is its contribution to an aesthetic archive of children learning how to symbolize grief and guilt. After the death of his father, Shaun's growth is inhibited and overwhelmed by the vicissitudes of hate, left generally unchecked by kindness or compassion. The death of his parent causes a loss of continuity as a self was in the midst of being made and known. Alongside making the case for the therapeutic potential of reparation, the film addresses England's ambivalence toward a history of colonial ruin and class conflict. A child's ability to recover from the loss of a parent is not guaranteed, but the provision of a potential space for mourning and reparation is integral to recouping from a fundamental dependence on someone who has died.

# Epilogue

## The Contested Design of Children's Sexuality

*The Queer Aesthetics of Childhood* has sought a conversation about children's suffering but has been resistant to fantasies of child rescue on behalf of perceived innocence. While I have critiqued notions of child protection, I have also pointed toward the harm done when the provision of love and safety is bypassed or refused. Thus this study has been a reckoning with both the need to help children "grow" and the social construction of childhood. Our commitments to rescuing children and measuring them against developmental milestones are fraught with injustice. I have not written toward the ambition of rescue, but rather, have sought to understand how theories of childhood impact the lived realities of children. Theorizing the forms of subjectivity enacted through the expressive cultures of childhood, I have offered critical readings of a range of aesthetic objects. The aim in doing so has been to broaden insight into the symbolic struggle of growing up and fitting in. In seeking commonality in child

124

studies and queer theory, this book has asked what there is to learn about child development in the cultural formations of art. I have discouraged rhetorics of childhood innocence and their attendant policies of child saving, all the while insisting that children's unique vulnerabilities and emotional tonalities be cared for. In addressing aggressions against the child and political ambivalences toward child protection, I have sought new theories of childhood that redeem the life-making capacities of children's development without reinvesting in their innocence. I have considered the biopolitics and transnational economies of capital, race, and sexuality in the making of childhood. The centrality of queer affect to this inquiry has been important because it offers a way to conceptualize what is not metabolized during the process of "development" and is impervious to the social logics of racism, nation-states, gender, and capitalism. Here, queer affect has helped to name the psychological, political, and aesthetic excesses of development that cannot be contained by normative theories of growth. Reading across and between disparate fields of inquiry and against disciplinary enclosures, I have tried to think with Muñoz's statement: "The future is only the stuff of some kids" (2009, 95).

In the form of an epilogue, I offer engagement with Chase Joynt's short film, *Genderize*, which sharpens recognition of children and youth's knowledge of sexuality. As furious and highly emotive debates about sex education erupt in the United States and Canada, *Genderize* helps to give voice to the young people caught within debates over what they should know. New combinations of social media, medical access to (and sometimes denial of) hormones and surgeries, and attempts to roll-back human rights legislations mean that

126    THE QUEER AESTHETICS OF CHILDHOOD

inclusive and contemporary sex education is urgent. In Ontario, from where I write, debates over children's sex education have also been limned with concern for the future of the nation.[1] Sex ed often becomes a focal point in election campaigns for politicians. In the United States, debates about the defunding of Planned Parenthood have recently repeated similar anxieties and collective worries. The social logics of gender, sex, and childhood, grafted onto the borders of the nation-state, mean that the debate over what should be included in children and youth's sex education is also about making and protecting the future of the nation. The child becomes a loaded transit point between political opinions. What becomes inscribed into the figure of the child has to do with the political future desired by adults (Briggs 2012; Castañeda 2002; Gill-Peterson 2018; Kincaid 1998; Stockton 2009).

As Kerry Robinson explains, "The strict regulation of children's knowledge of sexuality not only operates to constitute and maintain definitions of the child, youth and adult, but also relations of power within and across these categories" (2012, 270).[2] The child's future is speculative; thus the practice of educating children is an investment in what is forthcoming. Allowing children to determine their own exploration of the world is a gambling of future returns for the nation-state; thus, the pedagogical intervention of sex ed helps to conjure certain modes of futurity. Over and above its actual curricular lessons, sex education in schools is too often marshaled to accomplish the work of the adult's psychosocial needs and politics.[3] Yet, instead of deriding or shifting away from the necessity of teaching children about gender and sexuality, I lean into compulsions to create pedagogical spaces for such

learning by turning to the realm of the aesthetic. In keeping with *The Queer Aesthetics of Childhood*'s proposal that in art and cultural production we are confronted with the affective excesses of development, I engage with the film *Genderize* as a form of art that sharpens our understanding of child development's relationship to gender and sexuality. The film does not propose a best practice for teaching children about sexual identity, sexual desire, or the ways that bodies move, age, and transform. A consideration of the sequential development of the child, directed toward adulthood and its changing forms of embodiment, can be important and requires careful attention. Here, though, with the help of the film, I draw a different map of the psychological and cultural inscriptions operative in theories of child development. As Chase Joynt makes clear, a defensive suppression of knowledge cannot silence the child's inquiries into sexuality; they return, boisterous and indefensible, unfazed by the adult's verdict on developmental appropriateness. Rather than expressing surety about what is best for the child in relation to sex ed, and attempting to repress the child's attempts to match sexual curiosity to words, the film suggests that adults might listen ethically for what children can teach us about how anxiety instructs pedagogy and learning.

## The Child as Pedagogue

Joynt's film offers a curricular challenge as it invites viewers to learn about gender and sexuality *from* children and youth. The film provides a way to disrupt the placating of children's knowledge and experience, a by-product of tightly held beliefs that they are inert objects that need education imposed by

128 THE QUEER AESTHETICS OF CHILDHOOD

adults. Indeed, the young people in *Genderize* already know a great deal, and from them we gain an education in the social life of sexuality. The film is circulated online by CBC (Canadian Broadcasting Corporation) and is described on its website: "filmmaker Chase Joynt sat down with Benton (12), Madeleine (10), and Dexter (6) to talk about gender, puberty, school, and parents. Four years later, he revisited the kids to see what's changed—but not before the kids flipped the camera on the adults to ask some questions of their own." *Genderize* offers an edifice for thinking and learning about sexuality so that knowledge is stretched out to gather both young people and adults as pedagogues. The children in the film do not emphatically reroute the queer excesses of their development or ask for didactic lessons on appropriate behavior. Rather, they carefully explain how sex and sexuality are already at work in their lives. The film ends with the camera in the youths' possession, as they pose questions to the filmmaker and their own father about feminism, popular culture, and issues related to trans subjectivity.

The young stars of Joynt's film insist that beyond the boundaries of innocence, children and youth make vital contributions to the collective work of understanding sexuality. As *Genderize* makes clear, sexuality exceeds the adult's understanding as much as the child's, and our entrance into debates about children and youth's need for (or denial of need) sex ed is propelled as much by the adult's constellation of affective, libidinal, and political attachments to history. In *Histories of the Transgender Child*, Julian Gill-Peterson makes this point clear by studying the medical history of endocrinology and "the framing of sex through racial plasticity" (2018, 35). For Dexter, six years old and then ten during Joynt's second visit

FIGURE 4 Film still from *Genderize*. Courtesy of filmmaker Chase Joynt.

with the family, gender is a technology of the self that has helped classmates to perceive difference. Against vocabularies of shame that often shroud children and youth's explorations of gender, six-year-old Dexter explains that boyhood is tentative and contingent. A member of a distinct family form, subtended by whiteness and steered by a father (who makes an appearance in the film) who comfortably encourages curiosity about gender, feminism, and sexuality, the child's questions about what the world can handle of gender explorations are clearly supported in ways that other parents might not feel comfortable with. The private assembly of family and the public forum of liberal schooling come together neatly in this family, so that the father can help to consolidate his children's education in ways that encourage confidence to question the validity of what is presented in the classroom. In offering a chance for the viewer to hear from the child/youth, though,

130 THE QUEER AESTHETICS OF CHILDHOOD

Joynt successfully encourages consideration of the coalitional possibilities of adults, children, and youth learning together.

*Genderize* offers plenitude and potentiality to the sibling's knowledge of sexuality. Joynt ensures that they retain dignity while cinematically portraying the textures of their growth and curiosity. In their presence, Joynt is guided into a conversation about gender and sexuality that is about not only a systematic belief in the formation of alternative identities but also the affective attachments and emotional curiosities that are the foundations for knowledge acquisition. As the filmmaker shows, allowing curiosity to drive conversations with young people (rather than surety about what is most right for the child) opens up a pedagogical environment that is attuned to their questions and also their agency. *Genderize* proposes that sex ed should not be treated as a clearly defined set of lessons to be internalized within a specific developmental period, but a space to create conditions for self-determined futures and to try out techniques to survive the betrayals and pleasures of transforming bodies and building relationships. Joynt allows the camera to reach down and greet the children's gaze and curiosities. He also allows the children to hold the camera and greet his own gaze. In *Genderize*, the bristling symbolic economies of childhood and adulthood may be rethought as inextricable. In an effort to nuance the interdependencies of childhood, adolescence, and adulthood, Joynt arrives at a conversation with young people hoping to learn *from* them. The presumptive difference between this mode of relation and most others in the realm of sex education is a recognition of young people's enmeshment in politics and their work as engineers of complex social relations. Troubling the underpinnings of generational time that creates a binary

relationship between childhood and adulthood helps to form a broader and more porous conceptualization of sex ed that deconstructs the child's innocence along with the adult's assumed mastery. In offering an openness to children's questions, *Genderize* compels us to notice how a transference of depravity to young people seeks to swell adults' surety that they know best. Situating the film in a long history of pedagogical work that aims to greet children's curiosities about gender, sex, and sexuality, *Genderize* is a gift for thinking about what worlds we can build with children.

While my conceptualization of queerness in this book has exceeded gender and sexual identity, I have concluded with a short reflection on children's sex education because it is an example of how the adult's politics and fantasies of futurity impact the material lives of children. The concept of queer childhood has helped me to think against the restrictions of child development theories that don't stretch to meet the needs of all children. I have hoped to offer conceptual theorizing that is accountable and responsive to the needs of children left out of normative theories of development. Sex education that is inclusive and contemporary, while also acknowledging the racial history of childhood's plasticity (Gill-Peterson, 2018), has life-making capacities for LGBTQ children and youth. Withdrawing support and representation of queer, trans, and gender nonbinary issues from the school curriculum leaves children without necessary support and knowledge. The pragmatics of advocating for young people's right to comprehensive sex education fits within the goal of theorizing queer childhood. In this book I have sought to show how political and affective resonances between localized, transnational, and transhistorical events can be better

explained through attention to the construct of childhood innocence. When the figure of the innocent child is leveraged in political debates over sex education and attempts to revoke sex education in schools, the affective consequences are immense.

Highlighting the politically ambiguous work of the rhetoric of childhood innocence (and its related material practice) has helped to explain how the ideals of growing up can hurt children. While child development theories can help to offer support to children, they can also be a form of maintenance directed at those who do not conform to desired expressions of cultural capital, racialization, or gender, for example. Here, respect has been given to children not interpolated by normative developmental theory; I have studied their aesthetic expressions for the elisions and ruptures that refuse each assimilative gesture of inclusion based on notions of universal childhood. Fundamentally, this project has sought to provoke the political potential of child studies to acknowledge codified values inherent in child development theory. Child studies' transformative potentials are not yet met, and I have hoped to offer a contribution to the untangling of child studies from its potential entanglements with forms of structural violence. A portion of this effort has been a recognition of the entwined histories of colonialism and child development theory and a commitment to reformulating a sense of children's well-being in ways that acknowledge colonialism, genocide, heteronormativity, and the exertions of gendered subjectivities.

At the center of my theorizing has been a consideration of how the expressive cultures of childhood might forecast new modes of relationality that encourage a redistribution of

care, belonging, and political value. I have proposed that in children's art and art about childhood, we might notice the historical by-products of injustice; not necessarily frozen, but reimagined in ways that move toward a different future. The new political imaginaries symbolized in the aesthetics of childhood offer conceptual material with which to support the fragile process of growing up.

# ACKNOWLEDGMENTS

This book is the result of a collective effort to support my ideas and passions. Thank you to my former colleagues and students at Carleton University and now, the Department of Child and Youth Studies at Brock University. Thank you to those who have organized and attended symposiums, panels, and events at which work in progress has been presented. Thank you to Dina Georgis, whose patient mentorship has been incisive, untiring, and generous. Thank you to Patrizia Gentile and Pauline Rankin, who offered accommodation and dinners during which they helped me work through many of the ideas presented here. Laurie Kang, a long-time accomplice, offered a close reading of the manuscript in its entirety, which was grounding and inspiring. Thank you to Miranda Yeo and Jermaine Marshall, whose research assistance was keen and appreciated. Lisa Farley's efforts to make child studies a fun and relevant place to be leave a continued impression on my scholarship. Natalie Kouri-Towe, my brilliant friend and grad-school collaborator, joined me in conversations about this work that altered its routes many times. Thank you to Dina,

Chase Joynt, and Jasbir Puar for first reading my book proposal and offering comments that have propelled its betterment.

At Rutgers University Press, thank you to Kimberly Guinta for her commitment to the work and to Jasper Chang for invaluable editorial assistance. Gratitude to the assigned readers of the manuscript and its copyeditors, whose engagement with my ideas offered wonderful ways forward. The Dyers, Elliotts, Fanias, and Mecijas have long accompanied me on this journey. Thank you to all of them, especially Asa Dyer-Mecija and Casey Mecija, whose love sustains me. Asa, who was born during the writing of this text, deserves a special thank you for sharpening my theories of childhood and expanding my capacity for empathy and care. Casey, thank you for the phonic substance and measured notes that give this work and the new world it hopes for, a soundtrack.

# NOTES

## INTRODUCTION

1. Andre Green describes affective encounters: "[O]ne may imagine the affective process as the anticipation of a meeting between the subject's body and another body. The affect would seem to resemble both a preparation for such an eventuality and the effect of foreseeing it in an accelerated way" (1999, 312). His description may be useful in thinking about the meeting of the subject and the art object.
2. Tera W. Hunter, "The Long History of Child Snatching," *New York Times*, June 3, 2018, https://www.nytimes.com/2018/06/03/opinion/children-border.html.

## CHAPTER 1   QUEER TEMPORALITY IN THE PLAYROOM

1. Artist's description of photographs as appears in "The Age of Innocence: Children in Photography," *Huffington Post*, April 30, 2013; updated December 6, 2017, https://www.huffingtonpost.com/mutualart/the-age-of-innocence-children-in-photography_b_3172664.html.
2. Valerie Walkerdine (1988, 1990, 1997) and Erica Burman (2009, 2012, 2013) have produced a large body of scholarship that explores how developmental theory hurts some children.

138                                    NOTES

3. Though Winnicott expressed gratitude toward Klein for provoking thought about the reparative tendencies, he parted ways with both Klein and Freud in his emphasis on transitional objects and transitional space. Like other psychoanalytically minded theorists of aesthetic life, he understood creative impulses to be grounded in infancy and the concealed impressions left by childhood development. Winnicott added to psychoanalytic thought a more elaborative theory of how culture impacts the child's development because he insisted that the ability to creatively use the spaces between psyches and material objects was integral to adapting to the social world. These spaces in between, which he calls transitional, form a potential space for symbolization and inter-relationality.

4. In psychoanalysis, "working through" is described as the process of interpreting the past through repeating, explaining, and narrativizing/symbolizing. The phrase "working through" is meant to explain how one moves toward healing and/or integration.

5. Lucy McKeon, "What Does Innocence Look Like?," *New Yorker*, April 11, 2016, https://www.newyorker.com/culture/photo-booth/what-does-innocence-look-like.

## CHAPTER 2    ART AND THE REFUSAL OF EMPATHY IN *A CHILD'S VIEW FROM GAZA*

1. H. Dyer and D. Georgis, "Play Interrupted: Love and Learning Amidst Difficult Futures for the Children of Gaza," *Review of Education, Pedagogy and Cultural Studies* 39, no. 5 (2017): 431–435. In "Play Interrupted" we theorize discourses of innocence as they relate to concerns over Gazan children's loss of play. David Marshall has also written about the politics of Gazan children's play (2014, 2015). Thank you to Dina for thinking with me about transnational solidarity and childhoods lived in war.

2. Jermaine Marshall, one of this project's research assistants, importantly points out the correlation between the drawings being considered "disposable and dangerous" and the children being understood as "dangerous and disposable." Marshall also proposes that in thinking that the museum's children needed to be shielded from the art, "there took place a shift of sorts in sympathy from 'poor Gazan children, to our poor children.'"

## NOTES 139

3. Biopolitics describes modes of governance that turn life itself into politics, that is, the distribution of life and death as a technique of control administered by those in power. See Michel Foucault's book *The Birth of Biopolitics: Lectures at the College de France, 1978–1979*. Since Foucault, biopolitical theory has continued attempts to describe why/how some must die so others can live. Biopolitical theory seeks to describe how the valuation of life relies on the devaluation of others. It teases apart and assesses the epistemological framings of the human and tactics of managing populations.

4. This relationship led Freud to distinguish between "historical reality" and "material reality" (Freud and Strachey, 1974). The latter refers to the actual event and the first, their psychic reconstruction. Importantly, in their essay "Fantasy and the Origin of Sexuality" (1968) Jean LaPlanche and J. B. Pontalis will later revise Freud's notion of psychical reality so that it does not emphasize a binary between fantasy and reality, but rather, opens up fantasy as present in both the unconscious dream and waking life. They dissect Freud's original thinking on fantasy and reality to suggest that fantasy can also be used to explain secondary elaborations that are conscious desires for fiction. See Andre Green (1999) for further discussion of the distinction between historical reality and material reality.

5. Melancholia, like mourning, is a reaction to the loss of a loved object. But here, "an attachment of the libido to a particular person, had at one time existed; then, owing to a real slight or disappointment coming from this loved person, the object-relationship was shattered. The result was not the normal one of a withdrawal of the libido from this object and a displacement of it on to a new one, but something different. . . . [T]he free libido was not displaced on to another object; it was withdrawn into the ego (Freud and Strachey 1974, 159). The melancholic is stuck in the grieving process and cannot work through the loss of the object. There is a descriptive quality in Freud's writing on this dilemma that Cheng (2001) finds useful in an examination of the paradoxes of grief as it relates to racial formations in North America.

# 140 NOTES

## CHAPTER 3 THE QUEER REMAINS OF CHILDHOOD TRAUMA

1. Subjected to the effect of the adult environment and knowledge about what has come after, the childhood memory takes the shape of contemporary psychic demand. D. W. Winnicott wrote of the adult's possession of childhood memories: "Much is forgotten but nothing is lost" (1992, 147).

## CHAPTER 4 REPARATION FOR A VIOLENT BOYHOOD IN *THIS IS ENGLAND*

1. In September 2015, *This Is England '90* began to air on Channel 4. Since the 2006 release of Shane Meadows's film, *This Is England*, the television series (*This Is England '86*; *This Is England '88*, and then, the most recent offering) has kept the narrative alive for an audience's unquenchable desire to watch the film's protagonist, Shaun Fields, grow up.

2. Freud contributes a theory of aggression as fundamental to human existence. In *Civilization and Its Discontents* (1930, 2002), he probes the social injunction "Thou shalt love thy neighbour as thyself" (2002, 46) and proposes that, perhaps, the neighbor is not worthy of love and may have more "claim to my hostility and even my hatred" (46). He finds that civilization, in the service of Eros, seeks to "bind the members of the community libidinally to one another, employing every available means to this end" (46). He then, though, asserts that "the element of truth behind all this, which people are so ready to disavow, is that men are not gentle creatures who want to be loved . . . they are, on the contrary, creatures among whose endowments is to be reckoned a powerful share of aggressiveness" (48).

3. Meadows writes, "Skins appealed to me because they were like soldiers: they wore their outfits like suits of armor and demanded respect. There were playground myths that surrounded them and especially their Dr. Martens boots" (2007).

## EPILOGUE

1. The public debate over the curriculum continues to roar, and has been broadcast on television, informed the writing of

# NOTES

dozens of newspaper articles, and resulted in large public protests in front of schools and Ontario's Legislative Assembly.

2. On this point, see also Egan and Hawkes. "The attempts to resolve and regulate the child's sexuality have produced a paradoxical logic which clings to the presumptive asexual child while simultaneously creating various techniques to control and manage its sexuality once initiated" (2008, 356).

3. Jen Gilbert has notably offered a theory of sex education that demonstrates the ways in which adults and adolescents are bound-up in each other's education. In her words, "Thinking about sex education through the problem of relationality opens up the well-guarded distinction between adolescence as a social and historical construction and adolescence as a biological or physiological event. In the often dreary fights between social constructivism and essentialism, 'development' becomes either a description of adolescent experience or, more perniciously, a means to govern adolescent bodies" (2007, 48).

# REFERENCES

Ahmed, S. *The Cultural Politics of Emotion*. New York: Routledge, 2004.

Amar, P. "The Street, the Sponge, and the Ultra: Queer Logics of Children's Rebellion and Political Infantilization," *GLQ* 22, no. 4 (2016): 569–604.

Aries, P. *Centuries of Childhood: A Social History of Family Life*. New York: Vintage Books, 1962.

Barber, B., C. McNeely, C. Allen, R. Giacaman, C. Arafat, M. Daher, E. El Sarraj, M. Abdullouh, R. Belli. "Whither the 'Children of the Stone'? An Entire Life under Occupation." *Journal of Palestine Studies* 45, no. 2 (2015): 77–108.

Berlant, L. "Lauren Berlant Discusses Reading With." *Art Forum*, January 30, 2014. http://artforum.com/words/id=45109.

Bernstein, R. *Racial Innocence: Performing American Childhood from Slavery to Civil Rights*. New York: New York University Press, 2011.

Brennan, T. *The Transmission of Affect*. Ithaca, New York: Cornell University Press, 2004.

Briggs, L. *Somebody's Children: The Politics of Transracial and Transnational Adoption*. Durham, NC: Duke University Press, 2012.

Britzman, D. *Novel Education*. New York: Peter Lang, 2006.

———. *Lost Subjects, Contested Objects: Toward a Psychoanalytic Inquiry of Learning*. Albany: State University of New York Press, 1998.

Brown, R. N. *Hear our Truths: The Creative Potentials of Black Girlhood*. Champagne: University of Illinois Press, 2014.

# REFERENCES

Bruhm, S., and N. Hurley. *Curiouser: On the Queerness of Children.* Minneapolis: University of Minnesota Press, 2004.

Burman, E. "Between Identification and Subjection: Affective Technologies of Expertise and Temporality in the Contemporary Cultural Representation of Gendered Childhoods." *Pedagogy, Culture and Society* 20, no. 2 (2012): 295–315.

———. "Desiring Development? Psychoanalytic Contributions to Antidevelopmental Psychology." *International Journal of Qualitative Studies in Education* 26, no.1 (2013): 56–74.

———. "Resisting the De-radicalization of Psychosocial Analyses." *Psychoanalysis, Culture and Society* 13 (2009): 374–378.

Butler, Judith. *The Psychic Life of Power: Theories in Subjection.* Stanford: Stanford University Press, 1997.

———. *Precarious Life: The Powers of Mourning and Violence.* New York: Verso, 2004.

———. *Bodies that Matter: On the Discursive Limits of "Sex."* New York: Routledge, 1993.

Campt, T. M. *Listening to Images.* Durham, NC: Duke University Press, 2017.

Caruth, C. *Unclaimed Experience: Trauma, Narrative and History.* Baltimore, MD: Johns Hopkins University Press, 1996.

Casteñada, C. *Figurations: Child, Bodies, Worlds.* Durham, NC: Duke University Press, 2002.

Chen, M. Y. *Animacies: Biopolitics, Racial Mattering, and Queer Affect.* Durham, NC: Duke University Press, 2012.

Cheng, A. A. *The Melancholy of Race: Psychoanalysis, Assimilation, and Hidden Grief.* Oxford: Oxford University Press, 2001.

Cox, A. M. *Shapeshifters: Black Girls and the Choreography of Citizenship.* Durham, NC: Duke University Press, 2015.

Dinshaw, C., L. Edelman, R. A. Ferguson, C. Freccero, E. Freeman, J Halberstam, A. Jagose, C. Nealon, and T. H. Nguyen. "Queer Temporalities." *GLQ: A Journal of Lesbian and Gay Studies* 13, no. 2–3 (2007): 177–195.

Doane, J., and D. Hodges. *From Klein to Kristeva: Psychoanalytic Feminism and the Search for the "Good Enough" Mother.* Ann Arbor: University of Michigan Press, 1992.

Dumas, M.J. and J.D. Nelson. "(Re)Imagining Black Boyhood: Toward a Critical Framework for Educational Research." *Harvard Educational Review* 86, no. 1 (2016): 27–47.

## REFERENCES

Dyer, H. "Reparation for a Violent Boyhood: Pedagogies of Mourning in Shane Meadows's *This Is England*." *Pedagogy, Culture and Society* 25, no.3 (2017): 315–325.

Dyer, H., and D. Georgis. "Play Interrupted: Love and Learning amidst Difficult Futures for the Children of Gaza." *Review of Education, Pedagogy and Cultural Studies* 39, no. 5 (2017): 431–435.

Edelman, L. *No Future: Queer Theory and the Death Drive.* Durham, NC: Duke University Press, 2004.

Egan, D. R., and G. L. Hawkes. "Imperiled and Perilous: Exploring the History of Childhood Sexuality." *Journal of Historical Sociology* 21, no. 4 (2008): 355–367.

Eng, D. L. *The Feeling of Kinship: Queer Liberalism and the Racialization of Intimacy.* Durham, NC: Duke University Press, 2010.

Eng, D. L. and D. Kazanjian. *Loss: The Politics of Mourning.* Berkeley: University of California Press, 2002.

Erni, J. N. "Queer Figurations in the Media: Critical Reflections on the Michael Jackson Sex Scandal," *Critical Studies in Mass Communication*, no. 15 (1998): 158–180.

Failler, A. "Narrative Skin Repair: Bearing Witness to Representations of Self-Harm." *English Studies in Canada* 34, no. 1 (2009): 11–28.

Fanon, F. *Black Skin, White Masks.* New York: Grove Press, 1967.

———. *The Wretched of the Earth.* New York: Grove Press, 1963, 1967.

Farley, L. *Childhood beyond Pathology: A Psychoanalytic Study of Development and Diagnoses.* Albany: State University of New York Press, 2018.

———. "The Uncanny Return of Repressed History in Jonathan Hobin's in the Playroom: Playing beyond the Pleasure Principle." *Jeunesse: Young People, Texts, Culture* 6, no. 2 (2014): 15–34.

Farley, L., and A. Tarc. "Drawing Trauma: The Therapeutic Potential of Witnessing the Child's Visual Testimony of War." *Journal of American Psychoanalytic Association* 62, no. 5 (2014): 835–854.

Felsenthal, J. "Ebony G. Patterson Confronts Race and Childhood at the Studio Museum in Harlem." *Vogue*, April 5, 2016. http://vogue.com /13423538/ebony-g-patterson-studio-museum-harlem.

Foucault, Michel. *The Birth of Biopolitics: Lectures at the Collège de France, 1978–79.* Basingstoke, England: Palgrave Macmillan, 2008.

Freud, S. *Civilization and Its Discontents.* London: Penguin, 1930/2002.

Freud, S and J. Strachey. *The Standard Edition of the Complete Psychological Works of Sigmund Freud.* London: Hogarth Press, 1974.

## REFERENCES

Georgis, D. *The Better Story: Queer Affects from the Middle East*. Albany: State University of New York Press, 2013.

Gilbert, J. *Sexuality in School: The Limits of Education*. Minneapolis: University of Minnesota Press, 2014.

———. "Risking a Relation: Sex Education and Adolescent Development". *Sex Education: Sexuality, Society and Learning 7*, no. 1 (2007): 47–61.

Gill-Peterson, J. *Histories of the Transgender Child*. Minneapolis: University of Minnesota Press, 2018.

———. "The Value of the Future: The Child as Human Capital and the Neoliberal Labor of Race." *Women's Studies Quarterly* 43, no. 1–2 (2015): 181–196.

Gilroy, P. *The Black Atlantic Modernity and Double-Consciousness*. Cambridge, MA: Harvard University Press, 1995.

———. *Postcolonial Melancholia*. New York: Columbia University Press, 2005.

Gopinath, G. *Unruly Visions: The Aesthetic Practices of Queer Diaspora*. Durham, NC: Duke University Press, 2018.

Gordon, S. *Film, Feminism and Melanie Klein*. London: Routledge, 2010.

Green, A. *The Fabric of Affect in the Psychoanalytic Discourse*. London: Routledge, 1999.

Greenwell, G. "*A Little Life*: The Great Gay Novel Might Be Here." *Atlantic*, May 2015. https://www.theatlantic.com/entertainment/archive/2015/05/a-little-life-definitive-gay-novel/394436/.

Hagman, G. *Aesthetic Experience: Beauty, Creativity, and the Search for the Ideal*. Amsterdam: Rodopi, 2005.

Halberstam, J. *The Queer Art of Failure*. Durham, NC: Duke University Press, 2011.

Hartman, S. *Scenes of Subjection: Terror, Slavery, and Self-Making in Nineteenth Century America*. Oxford: Oxford University Press, 1997.

Hebdige, Dick. *Subculture: The Meaning of Style*. London: Methuen, 1979.

Herman, J. *Trauma and Recovery: The Aftermath of Violence*. New York: Basic Books, 1992.

Hinshelwood, R. D. *Dictionary of Kleinian Thought*. London: Free Associations, 1989.

Hudson, Peter James. "The Geographies of Blackness and Anti-Blackness: An Interview with Katherine McKittrick." *CLR James Journal* 20, no. 1–2 (2014): 233–240.

## REFERENCES

Hunter, T. W. "The Long History of Child Snatching." *New York Times*, June 6, 2018, https://www.nytimes.com/2018/06/03/opinion/children -border.html.

Hurst, Rachel Alpha Johnston. "What Might We Learn from Heartache? Loss, Loneliness, and Pedagogy." *Feminist Teacher* 20, no. 1 (2009): 31–34.

Joynt, C., dir. *Genderize*. Canadian Broadcasting Corporation. 2016. https://www.cbc.ca/shortdocs/shorts/genderize.

Kincaid, J. *Erotic Innocence: The Culture of Child Molesting*. Durham, NC: Duke University Press, 1998.

King, Wilma. *Stolen Childhood: Slave Youth in Twentieth Century America*. Bloomington: Indiana University Press, 2005.

Klein, M. *Love, Guilt, and Reparation, and Other Works*. Translated by C. J. M. Hubback. London: Hogarth Press, 1998.

———. *The Psychoanalysis of Children*. Oxford, England: Delacorte Press, 1975.

Klein, M., and J. Mitchell. *The Selected Melanie Klein*. New York: Free Press, 1987.

Klein, M., and J. Riviere. *Love, Hate, and Reparation*. New York: Norton, 1964.

Kofman, S. *The Childhood of Art: An Interpretation of Freud's Aesthetics*. New York: Columbia University Press, 1988.

LaCapra, D. *Writing History, Writing Trauma*. Baltimore, MD: Johns Hopkins University Press, 2014.

Laplanche, J., and J. B. Pontalis. "Fantasy and the Origins of Sexuality." *International Journal of Psychoanalysis* 49, no. 1 (1968): 1–18.

Lear, J. *Freud*. New York: Routledge, 2005.

Lebeau, V. "The Arts of Looking: DW Winnicott and Michael Haneke." *Screen* 50, no. 1 (2009): 35–44.

———. "Mirror Images: D W Winnicott in the Visual Field." In *Embodied Encounters: New Approaches to Psychoanalysis and Cinema*, edited by Agnieszka Piotrowska, 171–182. London: Taylor and Francis, 2014.

———. "'Stick That Knife in Me': Shane Meadows' Children." *Journal of British Cinema and Television* 10, no. 4 (2013): 878–889.

Leys, R. *Trauma: A Genealogy*. Chicago: The University of Chicago Press, 2000.

Lowe, L. *The Intimacies of Four Continents*. Durham, NC: Duke University Press, 2015.

Love, H. "Queers ———— This." In *After Sex? On Writing Since Queer Theory*, edited by Janet Halley and Andrew Parker, 180–191. Durham, NC: Duke University Press, 2011.

Marshall, D. J. "Existence as Resistance: Children and Politics of Play in Palestine," In *Politics, Citizenship and Rights*, edited by Kirsi Pauliina Kallio, Sarah Mills, and Tracey Skelton, 245–262. New York: Springer, 2015.

———. "Save (Us from) the Children: Trauma, Palestinian Childhood, and the Production of Governable Subjects." *Children's Geographies* 12, no. 3 (2014): 281–296.

Matthews, Sara. "In the Playroom (on Looking as Pedagogy)." July 17, 2013. https://saramatthews.org/2013/07/17/in-the-playroom/.

McKeon, L. "What Does Innocence Look Like?" *New Yorker*, April 11, 2016. http://www.newyorker.com/culture/photo-booth/what-does-innocence-look-like.

Meadows, S., dir. *This Is England* [Motion picture]. Britain: IFC Films, 2006.

———. "Under My Skin." *Guardian*, April 21, 2007. http://www.guardian.co.uk/ lm/2007/apr/21/ culture.features.

Meiners, E. *For the Children? Protecting Innocence in a Carceral State.* Minneapolis: Minnesota University Press, 2016.

Michaud, J. "The Subversive Brilliance of *A Little Life*." *New Yorker*, April 28, 2015. https://www.newyorker.com/books/page-turner/the-subversive-brilliance-of-a-little-life.

Middle East Children's Alliance. *A Child's View from Gaza: Palestinian Children's Art and the Fight against Censorship.* Berkeley: Pacific View Press.

Mosby, I. "Administering Colonial Science: Nutrition Research and Human Biomedical Experimentation in Aboriginal Communities and Residential Schools, 1942–1952." *Histoire sociale/Social History* 46, no. 91 (2013): 615–642.

Muñoz, J. *Cruising Utopia: The Then and There of Queer Futurity.* New York: New York University Press, 2009.

Musser, A. *Sensual Excess: Queer Femininity and Brown Jouissance.* New York: New York University Press, 2018.

———. *Sensational Flesh: Race, Power, and Masochism.* New York: New York University Press, 2014.

Ngai, S. *Ugly Feelings.* Cambridge, MA: Harvard University Press, 2005.

## REFERENCES 149

O'Pray, M. *Film, Form and Phantasy.* London: Palgrave Macmillan, 2004.

Owen, G. "Queer Theory Wrestles the 'Real' Child: Impossibility, Identity, and Language in Jacqueline Rose's *The Case of Peter Pan.*" *Children's Literature Association Quarterly* 35, no. 3 (Fall 2010): 255–273.

Phillips, A. *Winnicott.* London: Penguin Books, 2007.

———. *The Beast in the Nursery: On Curiosity and Other Thoughts.* New York: Vintage Books, 1998.

Pitt, A., and D. Britzman. "Speculations on Qualities of Difficult Knowledge in Teaching and Learning: An Experiment in Psychoanalytic Research." *Qualitative Studies in Education* 16, no. 6 (2003): 755–776.

Pollack, M. "Ebony G. Patterson." *Interview Magazine,* March 19, 2016. https://www.interviewmagazine.com/art/ebony-g-patterson.

Puar, J. K. *The Right to Maim: Debility, Capacity, Disability.* Durham, NC: Duke University Press 2017.

Qouta, S., R. Punamaki, and E. El Sarraj. "Child Development and Family Mental Health in War and Military Violence: The Palestinian Experience." *International Journal of Behavioural Development* 32, no. 4 (2008): 310–321.

Rabaia, Y., Saleh, M. H., & Giacaman, R. "Sick or Sad? Supporting Palestinian Children Living in Conditions of Chronic Political Violence." *Children & Society* 28 no. 3, 172–181.

Robinson, K. H. "'Difficult Citizenship': The Precarious Relationships between Childhood, Sexuality and Access to Knowledge." *Sexualities* 15, no. 3/4 (2012): 257–276.

Rose, J. *The Last Resistance.* London: Verso, 2007.

Said, E. *Culture and Imperialism.* New York: Knopf, 1993.

Schotten, C. H. "To Exist Is to Resist: Palestine and the Question of Queer Theory." *Journal of Palestine Studies* 47, no. 3 (2018): 13–28.

Sedgwick, E. *Touching Feeling: Affect, Pedagogy, Performativity.* Durham, NC: Duke University Press, 2003.

Sedgwick, E. K. "How to Bring Your Kids Up Gay." *Social Text* no. 29 (1991): 18–27.

Shalhoub-Kevorkian, N. "The Biopolitics of Israeli Settler Colonialism: Palestinian Bedouin Children Theorise the Present." *Journal of Holy Land and Palestine Studies* 15, no. 1 (2016): 7–29.

## REFERENCES

Sharpe, Christina. *In the Wake: On Blackness and Being*. Durham, NC: Duke University Press, 2016.

Sheldon, R. *The Child to Come: Life after the Human Catastrophe*. Minneapolis: Minnesota University Press, 2016.

Schuller, K. *The Biopolitics of Feeling: Race, Sex, and Science in the Nineteenth Century*. Durham, NC: Duke University Press, 2018.

Stockton, K. B. *The Queer Child, or Growing Sideways in the Twentieth Century*. Durham, NC: Duke University Press, 2009.

Tabar, L. "Disrupting Development, Reclaiming Solidarity: The Anti-Politics of Humanitarianism." *Journal of Palestine Studies* 45, no. 4 (2016): 16–31.

Tarc, A. *Literacy of the Other: Renarrating Humanity*. Albany: State University of New York Press, 2015.

Tomkins, S. *Affect Imagery Consciousness: Vol 1: The Positive Affects*. New York: Springer, 1962.

Walker, A. "The Body in between, the Dissociative Experience of Trauma." *Technoetic Arts* 13, no. 3 (2015): 315–322.

Walkerdine, V. *Daddy's Girl: Young Girls and Popular Culture*. Cambridge, MA: Harvard University Press, 1997.

———. *The Mastery of Reason: Cognitive Development and the Production of Rationality*. London: Routledge, 1988.

———. *Schoolgirl fictions*. London: Verso, 1990.

Winnicott, D. W. *The Child, the Family and the Outside World*. Cambridge, MA: Perseus Publishing, 1987.

———. *Playing and Reality*. London: Routledge, 2005.

———. "Transitional Objects and Transitional Phenomena—A Study of the First Not-Me Possession." *International Journal of Psycho-Analysis* 34 (1953): 89–97.

Yanagihara, H. *A Little Life*. New York: Doubleday, 2015.

# INDEX

aesthetics: and art, 2–3, 6–7, 9, 16, 22–23, 36, 45, 66, 73; and Blackness, 30, 45; and childhood, 1–5, 7, 12–13, 37, 66, 69, 133; as expression, 4, 10, 32–33, 12, 28, 45, 66; and film, 2, 107; of grief, 22, 73, 83, 80; and literature, 83, 87; and pedagogy, 78; of play, 42, 45; and psychoanalysis, 17, 21–23, 45; queer, 7, 15, 26; and settler-colonialism, 70, 85; and war, 78, 85

affect: and art, 13, 38, 62, 63, 70–73, 78–79; beyond law, 65; and childhood, 2, 4, 8–9, 22, 26, 32–33, 65, 75, 91, 125; and colonialism, 4, 67–68; and culture, 3, 7, 84; and curiosity, 3, 130; and emotion, 7, 65; and film, 107–109; in grief, 31, 77–78, 104; listening for, 72; in object relations, 21–22, 40, 42; and photography, 60; and play, 29, 37, 40, 47, 56, 80; queer, 3–5, 7–9, 30, 39, 57–58, 86, 91–93, 101, 122, 125; racial history of, 20, 31, 35, 105; theory, 6–7, 8, 137n1; and

trauma, 86, 89, 98–99, 103, 105
Ahmed, Sara, 8
Amar, Paul, 18–19
ambivalence, 24–25, 43–44, 50–52, 62, 68, 94, 109–111, 123
Ariés, Philippe, 19

Berlant, Lauren, 34, 57
Bernstein, Robin, 19, 54
biopolitics, 3, 30, 36, 55, 75, 125, 139n3
boyhood, 28, 31, 50, 53, 103–111, 113–114, 117, 119–120
Brennan, Teresa, 7–8, 21–22, 71, 78, 102
Britzman, Deborah, 27, 60, 78–79
Butler, Judith, 97–98, 121

Campt, Tina M., 71–72
capitalism, 3, 12, 17–18, 25, 38, 54–55, 64, 113, 125
Caruth, Cathy, 79, 83, 92, 95–96
Castañeda, Claudia, 18, 19, 126
Chen, Mel, Y., 6–7, 19
Cheng, Anne Anlin, 7, 48, 63, 81–83, 105, 139n5
citizenship, 13, 64, 69

151

# 152 INDEX

class, 4, 38, 55, 103, 106, 108–109, 114, 123. *See also* working class

colonialism: and aesthetics, 4; and art, 71, 73–74, 77–78; geography, 3; history of, 3, 12, 20, 105, 123, 132; and nation building, 20, 55, 65, 68; and racial classification, 12, 22; and science, 82; and trauma, 4, 68, 81; violence, 67–68. *See also* decolonial; settler colonialism

community, 4, 30, 74, 109, 111, 114

curriculum, 31, 126, 127, 131

decolonial, 23, 72, 82

development: critique of, 26, 38, 53, 55, 60, 127, 132; as trajectory, 5, 26, 38, 58, 95, 107, 124, 130

difficult knowledge, 48, 60, 62, 66

Edelman, Lee, 20–21, 54, 58

ego, 80, 89, 94, 110

emotion: and abuse, 23, 86–89, 91, 95–101; and aesthetic experience, 2, 7, 67, 79, 107, 109; and affect, 7–8; and art, 13, 23, 78; childhood, 2, 4, 6, 12–13, 32, 58, 125; and colonialism, 20, 71; and the depressive position, 115; and law, 65; and loss, 23, 68, 96, 102–104, 114, 122; and masculinity, 111; and pedagogy, 32, 107; and play, 29, 38, 42, 44, 49; result of heteronormativity, 13, 27; and temporality, 56, 58, 116; and trauma, 31, 47, 68, 80–81, 93, 104, 120; after violence, 115–116, 118, 121

Eng, David, 7, 58, 81

Failler, Angela, 98–99

Fanon, Frantz, 81–82

fantasy, 5, 26, 43, 45–46, 77, 115

Farley, Lisa, 7, 18, 47–52, 59

feminism, 128–129

feminist, 12, 20, 22–24

Freud, Sigmund, 20–22, 27, 41, 45, 48–49, 83, 112, 115–116

Gaza, 6, 28–30, 65–81, 84–85

gender: and embodiment, 6, 8, 9, 14, 23, 55, 106, 126, 128–133; and heteronormativity, 7; and history, 2, 54; normalcy, 5, 15, 17, 26, 120; and pedagogy, 126, 131; subjectivity, 4–5, 13–14, 19, 27, 125–127, 129–133

*Genderize*, 32, 125–131

geopolitics, 23, 61, 67, 79

Georgis, Dina, 6–9, 12, 22, 39, 72, 79, 88, 92–94, 107, 116

Gilbert, Jen, 117, 141n3

Gill-Peterson, Julian, 5, 18, 128

Gilroy, Paul, 113, 115–116, 119

Halberstam, Jack, 14, 57–58

Hartman, Saidiya, 77

Hobin, Jonathan, 28–29, 34–39, 41, 48–52, 55–57, 59–62

homophobia, 4, 12, 26–27, 55

Hurley, Nat and Steven Bruhm, 15

identification, 21, 50, 62, 72, 85, 116, 119

immigrants, 31, 103, 105, 109, 112–114, 116–117, 122

infant, 8, 21, 42, 44–46, 86, 110, 118

infantile, 6, 16, 18, 22, 42, 44

Joynt, Chase, 32, 125, 127–130

justice, 33, 47, 84; lack of, 3, 6, 18, 25, 55, 124, 133

Klein, Melanie, 21, 29, 39–46, 56, 59, 106–107, 110–111, 115, 119, 122

LaCapra, Dominic, 82, 95

LaPlanche, Jean, 139

Love, Heather, 5

Matthews, Sara, 60

Meadows, Shane, 31, 103–105, 107, 114, 120–123, 140

Meiners, Erica, 5, 71

melancholia, 2, 63, 81, 83, 90, 95, 101–103, 105, 118, 139n5

memory, 9, 39, 59, 63, 81, 94, 112

migrant, 17

Muñoz, José Esteban, 12–13, 125

# INDEX 153

narcissism, 33, 72, 89
nationalism, 28, 31, 105, 108–109, 114, 116, 122

object relations, 21–22, 39, 41–44, 99, 110, 112

Patterson, Ebony G., 28–29, 34–41, 46–47, 50–53, 55–57, 59, 61–63
pedagogy, 26, 31, 78, 104, 109, 127
Phillips, Adam, 9, 46
play: and affect, 29, 37, 47; and curiosity, 3, 43; and guilt, 44; as hopeful, 6; and interiority, 29; loss of, 138n1; and object relations, 39–46; and phantasy, 42–43; politics of, 28, 36, 46, 56; and queer affect, 7, 9, 39; and queer desire, 2; and queer temporality, 29, 37, 39, 56, 58; and racialization, 28, 48, 50–52; as repair, 35, 37–38, 46, 56, 62–63; space for, 35–38, 43–44, 48, 50, 59–61; with toys, 35; after traumatic experience, 80; as uncanny, 49; and unconscious, 46–47; value of, 35
postcolonial, 22, 115–116
Puar, Jasbir, 67–69, 76

queer: affect, 3, 6, 7–9, 30, 72, 88, 91–93, 103, 105, 122; desire, 2, 5, 7, 26, 89; feelings, 28, 105; forms of listening, 72, 83; and intimacy, 2; kinship, 28; remains, 88, 101–103, 105; spectrality, 57; subjectivity, 2, 14, 20–21, 26, 30, 39, 61, 103, 128, 131; temporality, 14, 21, 29, 37, 39–40, 56, 57–58
queer of color critique, 20, 22
queer theory, 4–5, 13–14, 20–21, 26, 32–33, 39, 72, 125

race: and capitalism, 18, 54–55, 113; discourse of, 116; history of, 3, 17, 20, 35, 54, 61, 83, 105, 128; and innocence, 17–20, 28, 34, 35, 48, 50–55, 61, 70; and melancholia, 48, 83, 105; and

nation, 105, 115; and subjectivity, 51, 53, 61, 113–114; and violence, 83, 105, 113, 122
racism, 6, 31, 36, 48, 51–52, 55, 61, 83, 105, 125
rights, 8, 11, 23, 65–66, 71, 125

Schuller, Kyla, 8
Sedgwick, Eve Kosofsky, 6, 14, 110
settler colonialism, 12, 19–20, 23, 29, 65, 67–70, 72–74, 77–78, 84–85. *See also* colonialism
sexuality, 2, 4–5, 8, 13–14, 32, 55, 97, 125–131
shame, 2, 26, 114, 129
Sharpe, Christina, 51
Sheldon, Rebekah, 5, 18
Stockton, Kathryn Bond, 5, 14–17, 32, 55, 87, 126
suffering: and childhood, 78–80, 84, 124; collective, 6, 82; evidence of, 68; internal experience of, 77, 89, 94; listening to, 72; making meaning from, 68, 81; and pain, 98, 105; and reparation, 105; representation of, 3, 64, 76, 84–85

Tarc, Aparna, 12, 47
trans childhood, 5, 25–26, 128, 130–131
transference, 21, 33, 47, 131

unconscious, 23, 41, 43, 48, 80–81, 119, 139n4

war: and children's development, 74–75, 84, 138n1; death resultant from, 31; experience of, 23, 29–30, 65, 67, 84, 105, 109; Falklands, 103; in Gaza, 6; geographies of, 12; protection from, 66; suffering from, 64, 73, 80, 85; visual representation of, 47, 60, 65, 67, 71, 74, 78, 80
working class, 103, 108–109, 114

Yanagihara, Hanya, 30, 86, 89–90, 93–95, 97, 100

# ABOUT THE AUTHOR

**Hannah Dyer** is an assistant professor of child and youth studies at Brock University, St. Catharines, Ontario, Canada.

**Available titles in the Rutgers Series
in Childhood Studies:**

Amanda E. Lewis, *Race in the Schoolyard: Negotiating the Color Line in Classrooms and Communities*

Donna M. Lanclos, *At Play in Belfast: Children's Folklore and Identities in Northern Ireland*

Cindy Dell Clark, *In Sickness and in Play: Children Coping with Chronic Illness*

Peter B. Pufall and Richard P. Unsworth, editors, *Rethinking Childhood*

David M. Rosen, *Armies of the Young: Child Soldiers in War and Terrorism*

Lydia Murdoch, *Imagined Orphans: Poor Families, Child Welfare, and Contested Citizenship in London*

Rachel Burr, *Vietnam's Children in a Changing World*

Laurie Schaffner, *Girls in Trouble with the Law*

Susan A. Miller, *Growing Girls: The Natural Origins of Girls' Organizations in America*

Marta Gutman and Ning de Coninck-Smith, editors, *Designing Modern Childhoods: History, Space, and the Material Culture of Children*

Jessica Fields, *Risky Lessons: Sex Education and Social Inequality*

Sarah E. Chinn, *Inventing Modern Adolescence: The Children of Immigrants in Turn-of-the-Century America*

Debra Curtis, *Pleasures and Perils: Girls' Sexuality in a Caribbean Consumer Culture*

Don S. Browning and Binnie J. Miller-McLemore, editors, *Children and Childhood in American Religions*

Marjorie Faulstich Orellana, *Translating Childhoods: Immigrant Youth, Language, and Culture* Don S. Browning and Marcia J. Bunge, editors, *Children and Childhood in World Religions* Hava Rachel Gordon, *We Fight to Win: Inequality and the Politics of Youth Activism*

Nikki Jones, *Between Good and Ghetto: African American Girls and Inner-City Violence*

Kate Douglas, *Contesting Childhood: Autobiography, Trauma, and Memory*

Jennifer Helgren and Colleen Vasconcellos, *Girlhood: A Global History*

Karen Lury, *The Child in Film: Tears, Fears, and Fairy Tales*

Michelle Ann Abate, *Raising Your Kids Right: Children's Literature and American Political Conservatism*

Michael Bourdillon, Deborah Levison, William Myers, and Ben White, *Rights and Wrongs of Children's Work*

Jane A. Siegel, *Disrupted Childhoods: Children of Women in Prison*

Valerie Leiter, *Their Time Has Come: Youth with Disabilities on the Cusp of Adulthood*

Edward W. Morris, *Learning the Hard Way: Masculinity, Place, and the Gender Gap in Education*

Erin N. Winkler, *Learning Race, Learning Place: Shaping Racial Identities and Ideas in African American Childhoods*

Jenny Huberman, *Ambivalent Encounters: Childhood, Tourism, and Social Change in Banaras, India*

Walter Hamilton, *Children of the Occupation: Japan's Untold Story*

Jon M. Wolseth, *Life on the Malecón: Children and Youth on the Streets of Santo Domingo*

Lisa M. Nunn, *Defining Student Success: The Role of School and Culture*

Vikki S. Katz, *Kids in the Middle: How Children of Immigrants Negotiate Community Interactions for Their Families*

Bambi L. Chapin, *Childhood in a Sri Lankan Village: Shaping Hierarchy and Desire*

David M. Rosen, *Child Soldiers in the Western Imagination: From Patriots to Victims*

Marianne Modica, *Race among Friends: Exploring Race at a Suburban School*

Elzbieta M. Gozdziak, *Trafficked Children and Youth in the United States: Reimagining Survivors*

Pamela Robertson Wojcik, *Fantasies of Neglect: Imagining the Urban Child in American Film and Fiction*

Maria Kromidas, *City Kids: Transforming Racial Baggage*

Ingred A. Nelson, *Why Afterschool Matters*

Jean Marie Hunleth, *Children as Caregivers: The Global Fight against Tuberculosis and HIV in Zambia*

Abby Hardgrove, *Life after Guns: Reciprocity and Respect among Young Men in Liberia*

Michelle J. Bellino, *Youth in Postwar Guatemala: Education and Civic Identity in Transition*

Vera Lopez, *Complicated Lives: Girls, Parents, Drugs, and Juvenile Justice*

Rachel E. Dunifon, *You've Always Been There for Me: Understanding the Lives of Grandchildren Raised by Grandparents*

Cindy Dell Clark, *All Together Now: American Holiday Symbolism among Children and Adults*

Laura Moran, *Belonging and Becoming in a Multicultural World: Refugee Youth and the Pursuit of Identity*

Hannah Dyer, *The Queer Aesthetics of Childhood: Asymmetries of Innocence and the Cultural Politics of Child Development*

Printed in the United States
By Bookmasters